THEN & NOW

PALM BEACH

OPPOSITE: Mar-a-Lago (Latin for "sea to lake") was the grand home of Marjorie Merriweather Post and then husband E.F. Hutton. The couple chose a 17-acre ocean-to-lake site for their new home. Unsatisfied with designs from Marion Sims Wyeth, Marjorie selected Joseph Urban to complete the project. Urban's design would cost $2.5 million and would take four years to complete. In 1927, the Huttons moved into their new home, which became the scene for splendid seasonal social events. In 1969, it was designated a National Historic Landmark site. After Marjorie died in 1973, her estate was willed to the US government but was returned because of high maintenance costs and security considerations. In 1985, Donald J. Trump purchased the house, restored it, and opened the Mar-a-Lago Club in 1995. (Courtesy Historical Society of Palm Beach County.)

THEN & NOW

PALM BEACH

Richard A. Marconi
and the Historical Society
of Palm Beach County

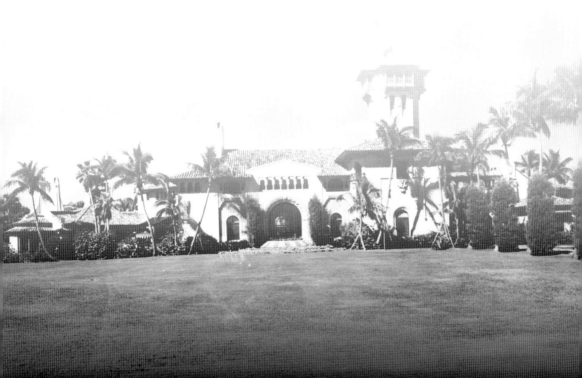

Library of Congress Control Number: 2012946552

Published by Arcadia Publishing
Charleston, South Carolina

Printed in the United States of America

Then and Now is a registered trademark and is used under license from
Salamander Books Limited

For all general information, please contact Arcadia Publishing:
Telephone 843-853-2070
Fax 843-853-0044
E-mail sales@arcadiapublishing.com
For customer service and orders:
Toll-Free 1-888-313-2665

Visit us on the Internet at www.arcadiapublishing.com

On the Front Cover: After The Breakers hotel burned for a second time in 1925, it was rebuilt using fireproof materials. The hotel was completed and reopened for the following 1927 season. The original hotel, built by Henry M. Flagler, was called the Palm Beach Inn. Flagler later changed the name to The Breakers because guests kept asking to stay "down by the breakers." Designed in the Italian Renaissance style, The Breakers stands as a symbol of Palm Beach luxury. Today, the palm tree–lined driveway leads visitors and guests to a security checkpoint before entry onto the grounds. This helps protect the privacy of hotel guests. (Then, courtesy of Historical Society of Palm Beach County; now, courtesy of the author.)

On the Back Cover: Since the 1890s, the beach has been a popular pastime of residents and guests alike. This 1950s image, taken just north of Worth Avenue on South Ocean Boulevard, is of the Palm Beach Municipal Beach and shows a beach packed with visitors enjoying sun and surf. (Courtesy of Historical Society of Palm Beach County.)

Contents

ACKNOWLEDGMENTS

I would like to thank the Historical Society of Palm Beach County for the use of its photographic collections for this book. This work would not have been possible without the historical society. A special thank you goes to my publisher, Maggie Bullwinkle, for her support, advice, and patience; my sincerest thanks goes to Debi Murray, chief curator of the Historical Society of Palm Beach County, for her extraordinary editing skills and for her ability to gently push you in the right direction to succeed; to my friend Janice Owens, former director of education and associate director of the Preservation Foundation of Palm Beach, for her edits of the manuscript; and to Jane Day, thank you for clarifying the house Tree Tops. Finally, my appreciation and love to my wife, Diana, for her understanding and support during the completion of the book. I have tried to make sure that the facts are correct, and any factual mistakes are mine and not anyone else's.

Unless otherwise noted, all "then" photographs are courtesy of Historical Society of Palm Beach County, and all "now" photographs are courtesy of the author. The "now" images are from the author's perspective of what he observed while traveling through Palm Beach.

INTRODUCTION

Fabulous Palm Beach is synonymous with the rich and famous, picturesque estates, stunning architecture, high-end shopping and fine dining on Worth Avenue as well as a perfect climate and beautiful beaches. It is truly the premier winter playground of high society. As striking as this small town is, it only has a year-round population of approximately 10,000 that balloons to over 30,000 during the winter season. Even so, it has undergone great change—from an area that was once noted for its natural beauty to a place that has been transformed by the human hand. Through photographic images, the reader goes from what once was here to what is here now, with some places not changing all that much and others changing for better or worse, depending on your viewpoint.

When the early pioneers arrived on Palm Beach in the 1870s, they found a jungle paradise. The vegetation was so thick settlers had to crawl on their hands and knees just to mark out their land claims. With no roads or railroads, they had to carve trails through the jungle just to get from one house to the other or from the lake to the ocean. Most pioneers owned some sort of boat to travel up and down Lake Worth, the highway of the day. It was this natural beauty that drew these first settlers to Palm Beach. In turn, they wrote home to tell family and friends about the bountiful land and wonderful climate they found in Southeast Florida.

During the last decade of the 19th century, Palm Beach entered a new era, the Gilded Age. With the coming of Standard Oil partner and Florida developer Henry M. Flagler, the tranquil paradise of Palm Beach changed. Flagler set off the first land boom when he purchased property to build the Hotel Royal Poinciana (opened 1894), which was destined to become the largest wooden resort hotel in the world. That same year, Flagler's Florida East Coast Railroad arrived in West Palm Beach, making it easier for visitors to travel to this once hard-to-reach place. This was followed two years later by the construction of the Palm Beach Inn, later renamed The Breakers hotel. Large-scale tourism was introduced to the area as the wealthy came in droves to escape the frigid Northern winters.

The next major change came when architect Addison Mizner arrived in Palm Beach in 1918. It was his friendship with Singer Sewing Machine heir Paris Singer that launched Mizner's Palm Beach architectural ventures. Mizner changed the landscape of the island when he introduced Spanish Mediterranean Revival–style architecture. Rich patrons sought him out to design large, grandiose mansions on properties that extended from Lake Worth (now part of the Intracoastal Waterway) on the west to the Atlantic Ocean on the island's east side.

During the mid-1920s land boom, monumental private and public construction projects were built in Palm Beach. Many different architects designed beautiful stone buildings that are still standing in the town, including the town hall, Episcopal Church of Bethesda-by-the-Sea, Paramount Building, the new Hotel Palm Beach, Whitehall Hotel, and St. Edward Catholic Church, to name a few. Some of these structures have been modified since their construction.

Following World War II, Palm Beach once again underwent change. Architects of the postwar era introduced more modern and efficient style homes. Some of the owners of the large 1920s-era mansions

now found their homes undesirable and too costly to maintain. Thus, they were sold, demolished, and subdivided, and new houses with modern conveniences were constructed. The town has been able to maintain its allure by melding historic structures with contemporary architecture. Lately, there has been a resurgence of the Spanish Mediterranean Revival style of architecture. Now, it is difficult to tell if a house was built in the 1920s or the 2000s.

In 2011, the Town of Palm Beach turned 100. As residents, local government, and organizations look to the next century, preservation of historic buildings, sites, and landscapes are of foremost importance. Over the last couple of decades, several hundred buildings have been demolished in Palm Beach to make way for businesses, condominiums, and new single-family residences. Through urban renewal, various historic private and commercial buildings have been saved from the wrecking ball and reconfigured for use today.

Through the use of old and new photographs, the reader will take a stroll down some of Palm Beach's thoroughfares to see a blend of the days of yore and now. Some places are well known to most, while others have been largely forgotten because they have been dismantled and replaced or the history of a site has been misplaced. Then & Now *Palm Beach* will bridge this historic town's past with the present.

ON THE LAKE TRAIL

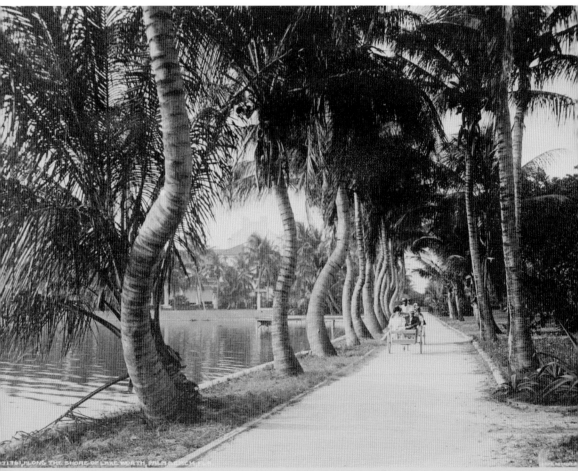

One of the oldest byways in Palm Beach is the Lake Trail, which runs north from the Royal Park Bridge to the present-day Sailfish Club. The settlers on Palm Beach built their homes along the sandy trail overlooking Lake Worth. Eventually, pioneer homes gave way to beautiful mansions, condominiums, and manicured hedges. The trail is now a scenic bicycle path and walkway.

On South Lake Trail at Pendleton Avenue is a state historical marker identifying the approximate location of Palm Beach's first hotel. In 1880, Elisha N. Dimick, the future first mayor of Palm Beach, added eight rooms to his house and opened the Cocoanut Grove House. By 1888, the hotel had 50 rooms. In 1893, he sold it to Philadelphia millionaire Charles J. Clarke. It burned down just months after he bought it. On the old hotel property, Clarke built his estate Primavera.

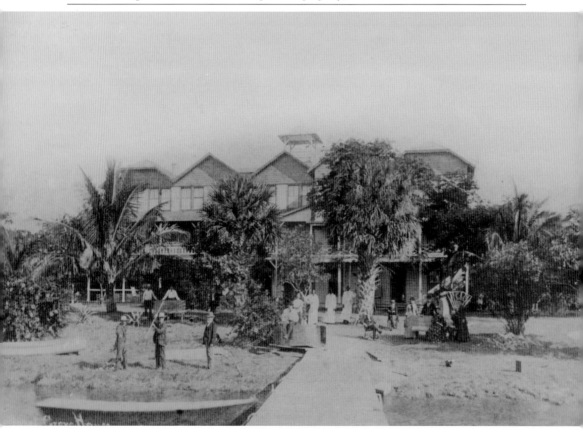

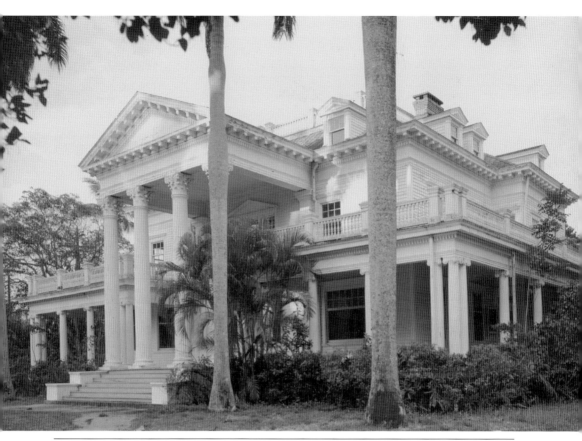

Edmund M. Brelsford completed building the Banyans, a Greek Revival–style house, in 1903. The Brelsfords' home took its name from a large banyan tree on the property. The Banyans was eventually purchased and demolished by the Royal Poinciana Chapel. In 2010, the chapel dedicated the Olivia Kiebach Garden in honor of the late philanthropist Olivia Kiebach. Mario Nievera designed the picturesque garden. A century-old ceiba tree still stands on the lot's southwest corner.

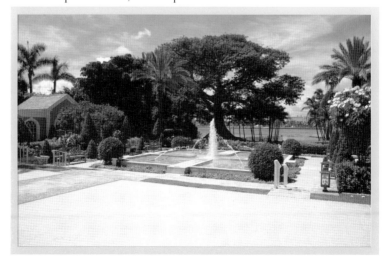

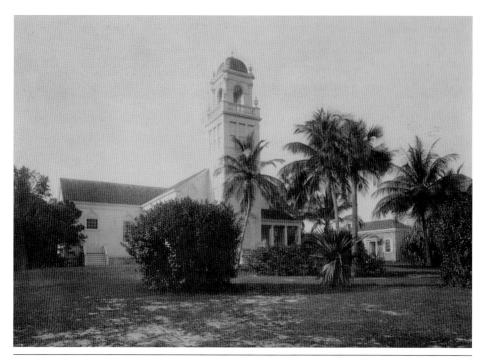

J.W. Ingle designed the Victorian Gothic–style Royal Poinciana Chapel, and builder George Lainhart oversaw the construction, which began in 1897 and was completed the following year. The 400-seat nondenominational church was originally located in the gardens of the Hotel Royal Poinciana. The church has been renovated and moved several times. It is now located at 60 Cocoanut Row near Sea Gull Cottage and the Henry Morrison Flagler Museum. In 2010, the chapel completed a $120,000 beautification, including a new garden.

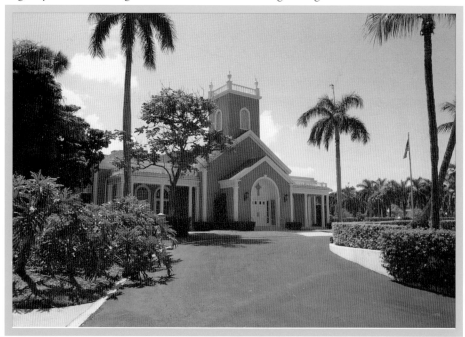

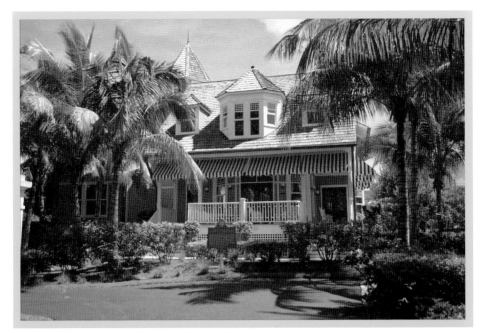

The Royal Poinciana Chapel owns the recently renovated Sea Gull Cottage. The Queen Anne shingle-style house was completed in 1886 for Denver businessman Robert R. McCormick just north of its present location. In the 1890s, Henry Flagler purchased the house as his winter residence in Palm Beach. It was later moved to the ocean side and used by The Breakers as a cottage. To avoid demolition in the 1980s, it was moved to its present location, 58 Cocoanut Row, and renovated.

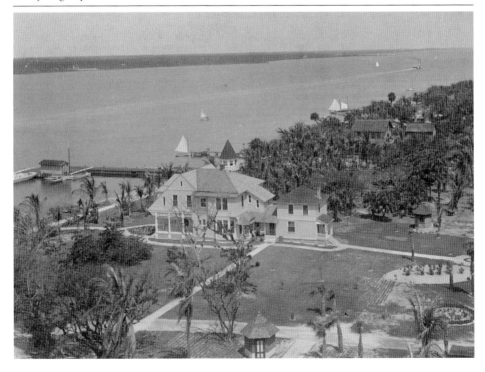

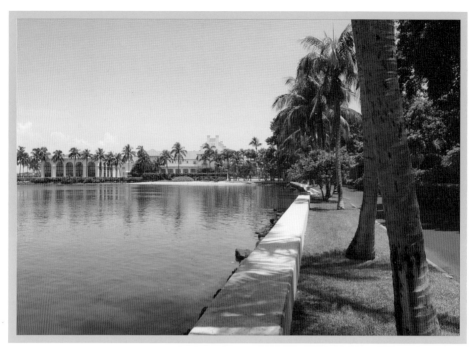

In 1880, brothers Edward and John Brelsford purchased a point of land jutting into Lake Worth from Frank Dimick. Brelsford's Point, as it was called, became the site of their store and the Palm Beach Post Office. When Henry Flagler arrived in the 1890s, the Brelsfords sold most of their land to him. The palm tree–covered historic point of land has been greatly altered. On it, Flagler built his winter residence, Whitehall, which is now the Henry Morrison Flagler Museum.

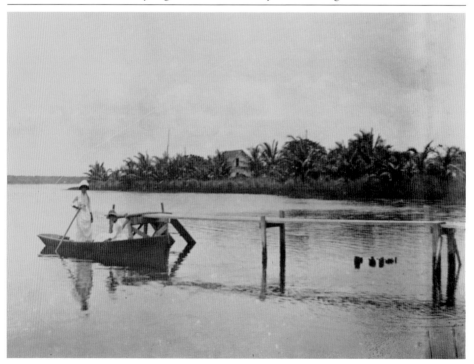

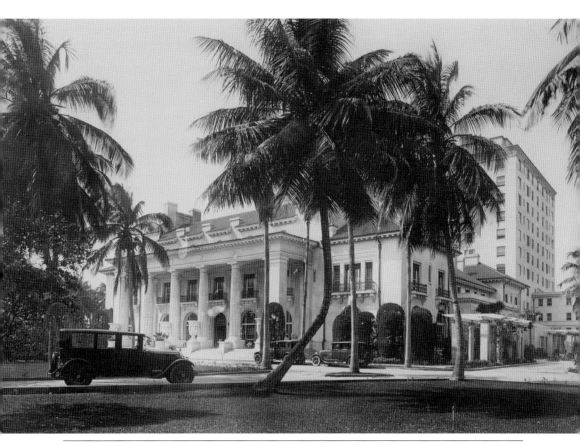

In the 1920s, Henry Flagler's 1902 Beaux Arts–style Whitehall, a gift for his third wife, Mary Lily Kenan, was sold to developers. It was converted into the Whitehall Hotel with a 10-story structure added onto the west side. In 1959, Jean Flagler Matthews bought the hotel and founded the Henry Morrison Flagler Museum. The Gilded Age masterpiece, designed by John Carrere and Thomas Hasting, was renovated and is now a National Historic Landmark museum dedicated to Flagler and the Gilded Age.

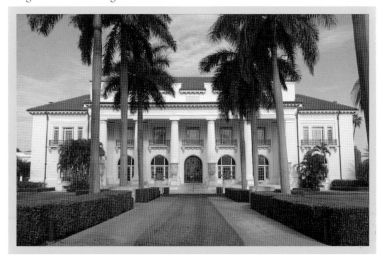

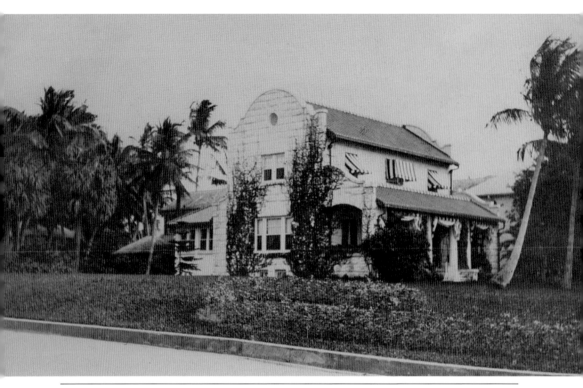

Pleasant View, Edward R. Bradley's home, faced Lake Worth just north of his famous Beach Club, a restaurant and gambling casino. Located at Sunset Avenue and Lake Trail, both buildings were demolished in the 1940s after Bradley's death, and the land was deeded to the town for a park. During the demolition of the house, a wall and pagoda-style mantle and fireplace were saved. Now known as Bradley Pavilion, it is located on the north side of Bradley Park.

Constructed in the 1960s, the Royal Poinciana South apartment building overlooks the Intracoastal Waterway and Bradley Park. The original occupant of the site was Villa Sonia, built for John Bradley, brother and partner of Edward R. Bradley. In 1920, Louis Kaufman of New York purchased the Dutch Colonial–style villa and the adjacent lot and home of Harold Vanderbilt. The present building features 86 furnished and unfurnished apartments and penthouses.

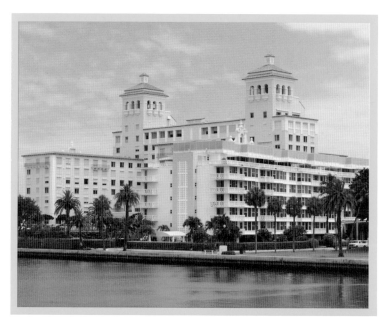

The exclusive Biltmore Condominium sits on the location of the original Hotel Palm Beach. The 1902 hotel, owned by Sidney Maddock, burned in 1925, and from the ashes rose the Hotel Alba, later renamed the Biltmore. During World War II, the Coast Guard transformed it into a training base. Billionaire John D. MacArthur purchased the hotel in the 1970s and then sold it. In the 1980s, the new owners converted the twin-towered building into a 128-unit condominium on Bradley Place.

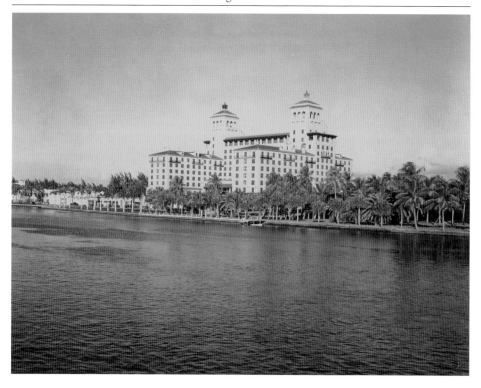

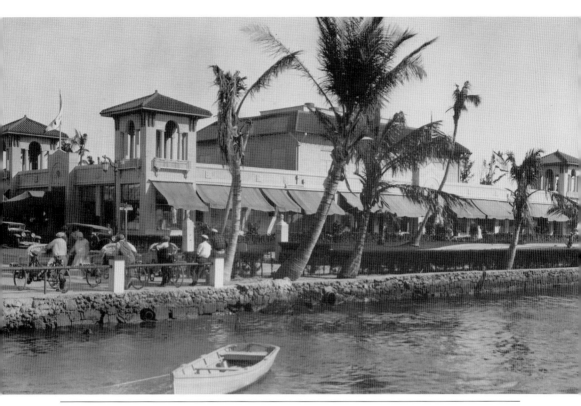

On the Lake Trail between Seminole and Everglades Avenues, August Geiger designed the 1917 Fashion Beaux-Arts building for Stanley Warrick as a combination retail center and theater. It sold in 1944, and by the 1980s, the building was demolished to make way for the plush L'Ermitage condominium. The $60-million complex of both condominiums and town houses lies between Seminole and Atlantic Avenues, between Lake Trail and Bradley Place.

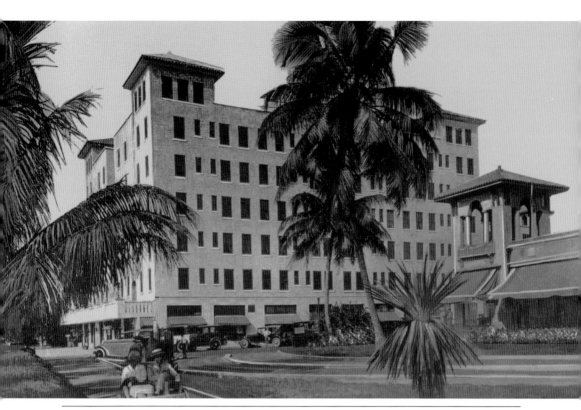

Overlooking the Lake Trail at the foot of Everglades Avenue, the $2-million, 208-room Royal Daneli opened in 1924. Six years later its name was changed to the Hotel Mayflower. By 1961, it was the Palm Beach Spa and Hotel, catering to Washington, DC, political clientele. The spa was closed and sold to the Harlon Group, who demolished the building and replaced it with the L'Ermitage town houses designed by Eugene Lawrence.

In 2007–2008, the Maddock family subdivided their historic properties that included Duck's Nest, old Bethesda-by-the-Sea, and Tree Tops into the eight-lot Landmark Estates subdivision. Part of the project included the razing of Tree Tops (pictured here), a late-19th-century two-story shingle house. The lot on the south side of old Bethesda is now empty. The lots with Bethesda and Duck's Nest remain with the Maddock family. In 2010, two lots sold for a combined price of $15 million.

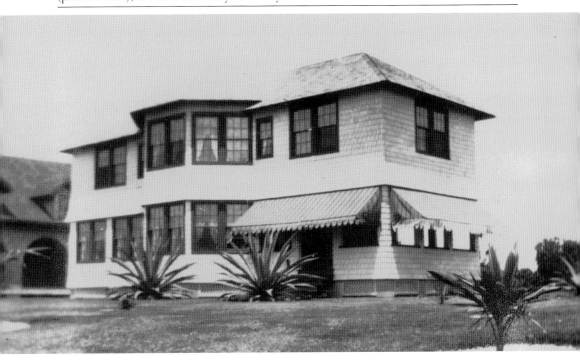

On North Lake Trail, overlooking the Intracoastal Waterway (Lake Worth), is the old Episcopal Church of Bethesda-by-the-Sea. The second of three Bethesda-by-the-Sea churches, this shingle-style structure was built in 1894 to replace the smaller 1889 church located nearby. To attend services, parishioners traveled by boat or along the Lake Trail. It was deconsecrated in 1925 when a new church was constructed at 141 South County Road. The old building is now a private residence owned by the Maddock family.

Another Maddock-owned house is the 1891 house, Duck's Nest, located on North Lake Trail. The prefabricated house was shipped from New York and erected for Henry Maddock on the adjacent north lot of the old Bethesda Church. The name of the house came from ducks that once nested in the area and for "Duckie," Henry's nickname for his wife.

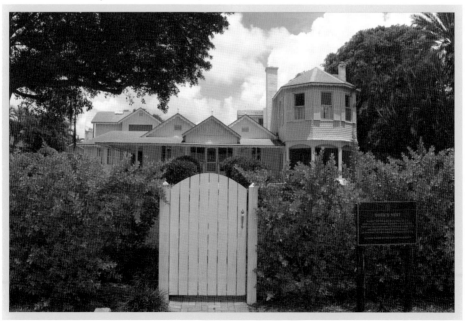

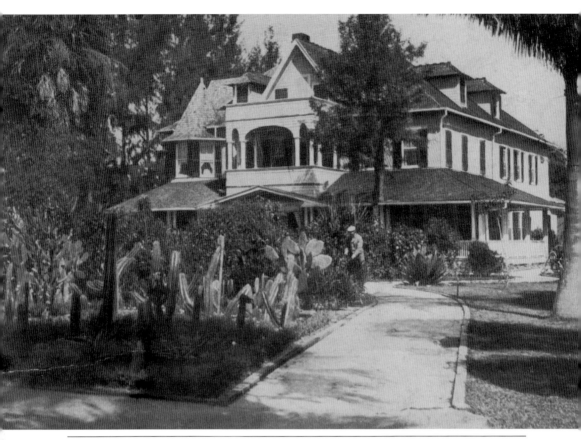

In 1887, Charles and Frances Cragin of Philadelphia purchased 20 acres from Moore Dimick at the north end of Palm Beach. They built and named their house Reve d'ete, "Dream of Summer," and planted a large garden, ultimately covering 250 acres with hundreds of varieties of trees, shrubs, flowers, and cacti. Though it became an attraction, it was sold in 1925 and is now a subdivision, remembered only through the names of residential streets like Garden (pictured here), Adam, and Eden.

CHAPTER 2

ROYAL PALM WAY

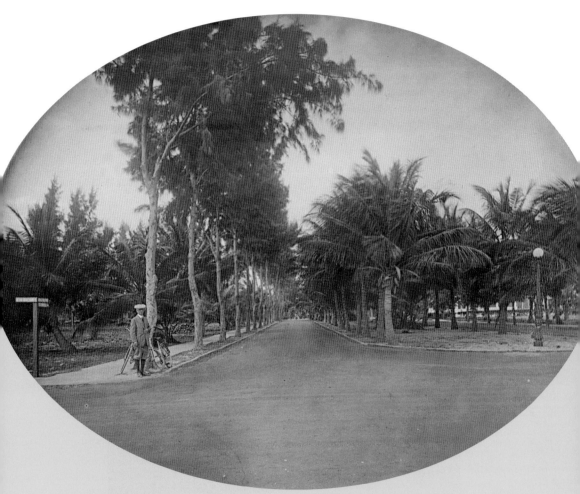

Royal Palm Way is an east-west artery through one of Palm Beach's oldest subdivisions, Royal Park. The design for this striking street with tall royal palms is based on Chicago's Drexel Boulevard. A hotel, businesses, financial institutions, a school, and the Society of the Four Arts have replaced the homes that once lined the street from lake to ocean.

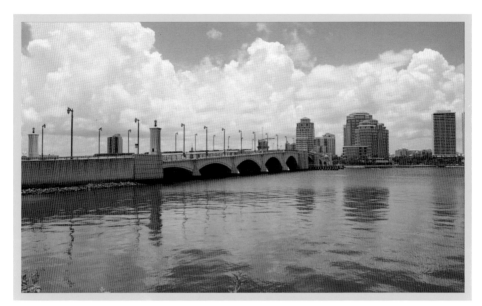

In 1911, a wooden bridge opened between Palm Beach and West Palm Beach. The Palm Beach Improvement Company constructed the toll bridge so land buyers could easily travel to the new Royal Park subdivision. Ten years later, a new bridge went up but before opening, it collapsed. A replacement bridge opened in 1924 and was rebuilt once again 15 years later. A new $51-million, four-lane bridge opened in 2004 to replace the timeworn Royal Park Bridge.

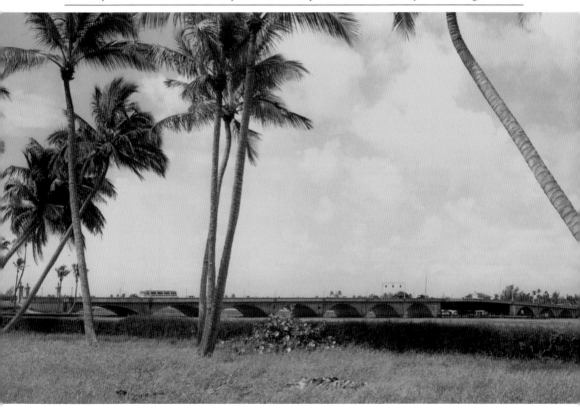

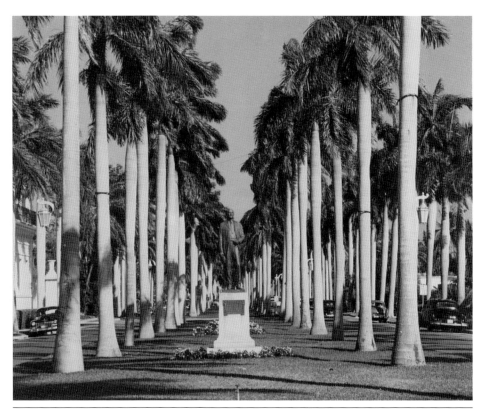

The first Palm Beach mayor, Elisha Dimick, greets visitors as they enter Palm Beach from the Royal Park Bridge. The bronze statue of Palm Beach hotelier, businessman, codeveloper of the Royal Park Subdivision, state representative, and senator honors him. When it was dedicated in 1922, three years after his death, it was erected in West Palm Beach. Twenty-five years later, it was moved to a more proper home, near the bridge on Royal Palm Way.

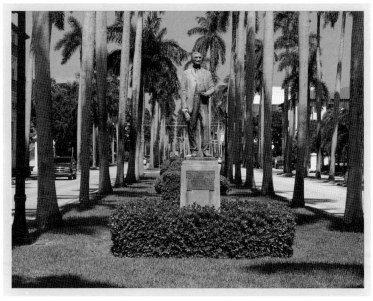

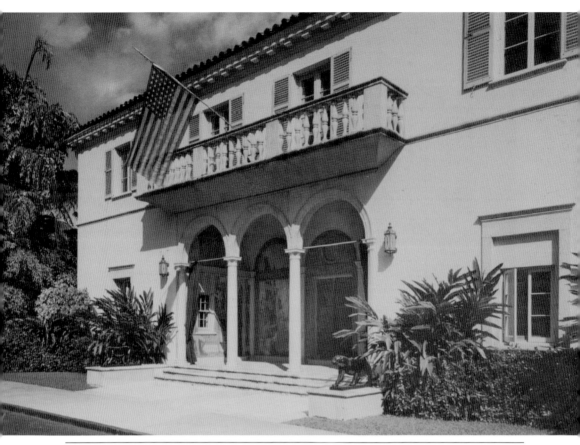

Organized in 1936, the Society of the Four Arts commissioned Maurice Fatio to design a gallery for the organization. Fatio designed an Italian Renaissance–styled headquarters for the society. In 1939, the Society of the Four Arts received murals painted by Albert Herter, depicting drama, visual arts, music, and literature to decorate the loggia. The bronze panthers were added in the 1940s. The building is now the Gioconda and Joseph King Library, which houses 65,000 books, periodicals, and Addison Mizner's personal library.

In 1930, Edward R. Bradley opened the Mizner-designed Florida Embassy Club at 439 Royal Palm Way, just east of the Royal Park Bridge. When the club closed its doors, the Society of the Four Arts bought it in 1947, and architect John Volk converted the building for the society's use. During the renovation, the entrance was moved from Royal Palm Way to the north side. Renamed the Esther B. O'Keefe Gallery Building, it houses an art gallery and a 700-seat auditorium.

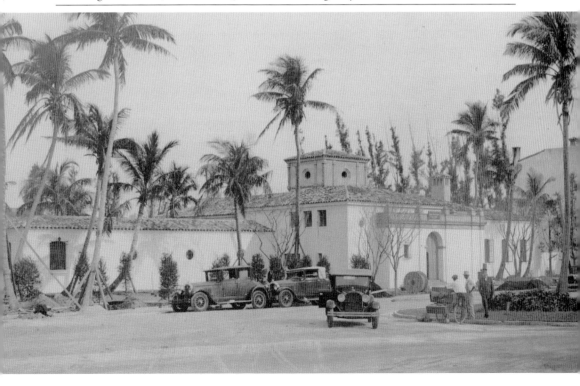

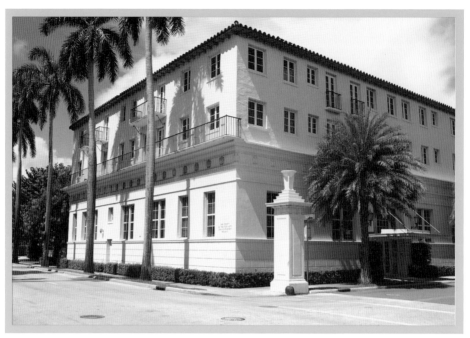

Renovated in the 1990s, the old Embassy Apartments at the northwest corner of Royal Palm Way and Four Arts Plaza (once called Ceiba Avenue) is the Four Arts' John E. Rovensky Administration Building. Addison Mizner designed the office/apartment building in 1925 and now offices and a children's library are located in the structure. In the 1990s, the organization paid $1.35 million to add it to the growing campus of the Society of the Four Arts.

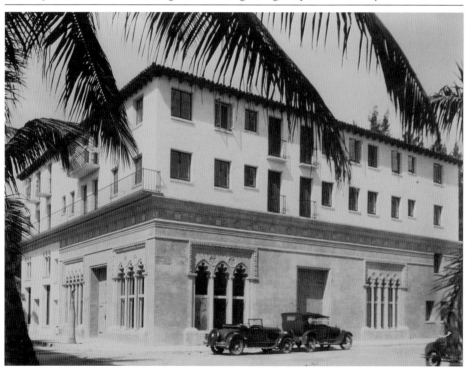

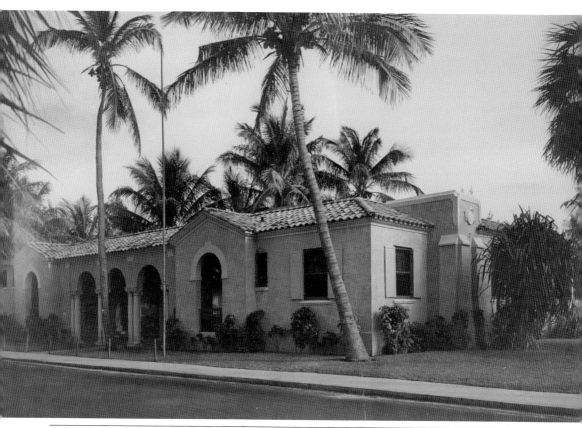

In 1921, R.H. Tremble designed Palm Beach Public School at Cocoanut Row, between Seaview Avenue and Royal Palm Way. Originally an elementary school, additions were made over the years to include a west campus for the junior high school, designed by architect William Manly King. The old Palm Beach Public School was demolished, and a new $13.4-million state-of-the-art school opened in 2006. Over 400 elementary school students attend the new school that was constructed on the grounds of the original school.

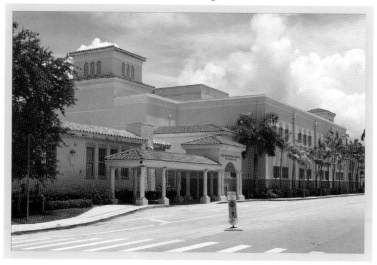

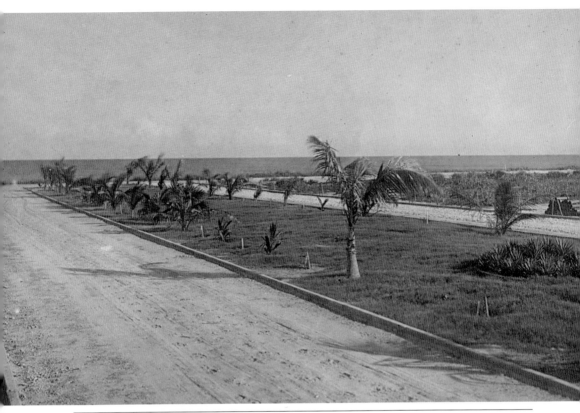

The east end of Royal Palm Way terminates at South Ocean Boulevard at the ocean beach. When the road opened, there was nothing standing on the corners, and the median only contained small palm trees. At the time, there were only two single lanes. Not much has changed since the early 20th century except the palm trees are taller, a bank building and condominium now occupy each corner, and a flagpole stands at the intersection.

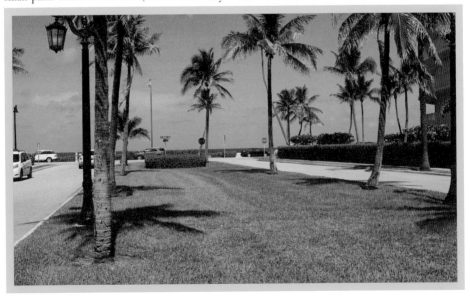

ROYAL POINCIANA WAY

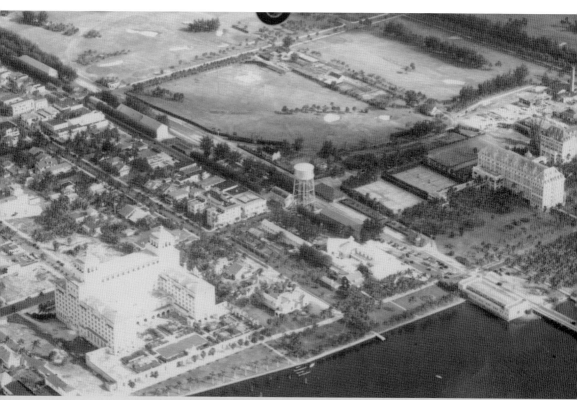

Originally know as Main Street, this thoroughfare was one lane with barracks for hotel workers, the train station, and businesses. In the 1930s, the railroad tracks were removed, and the road was expanded. The town changed the street name to Royal Poinciana Way in 1938. The royal palm–lined boulevard is the north entrance into Palm Beach via the Flagler Memorial Bridge.

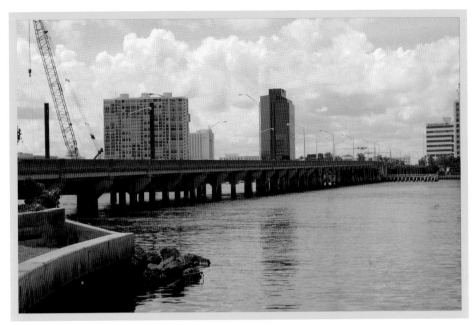

Construction of a new $94-million Flagler Memorial Bridge began in 2012 to replace the decaying and outdated 1938 bridge. The original wooden bridge built at this site opened in 1901 and was a railroad and pedestrian bridge. The bridge allowed the Florida East Coast Railway to drop passengers off at the hotels. In 1938, a new a concrete bridge opened between West Palm Beach and the island.

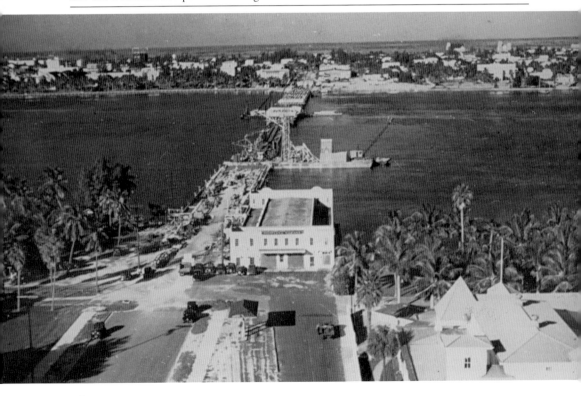

ROYAL POINCIANA WAY

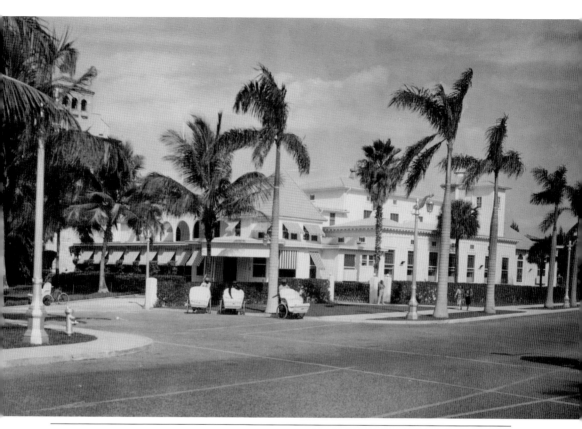

Located on Royal Poinciana Way at Flagler Memorial Bridge is Bradley Park. In 1898, Edward R. Bradley opened the Beach Club, a restaurant and gambling establishment, becoming one of the few evening activities available during the winter season. To ensure success of the exclusive, non-Florida residents' club, women were allowed to gamble after the first season. After Bradley's death in 1946, the club was razed and the land converted into a town park.

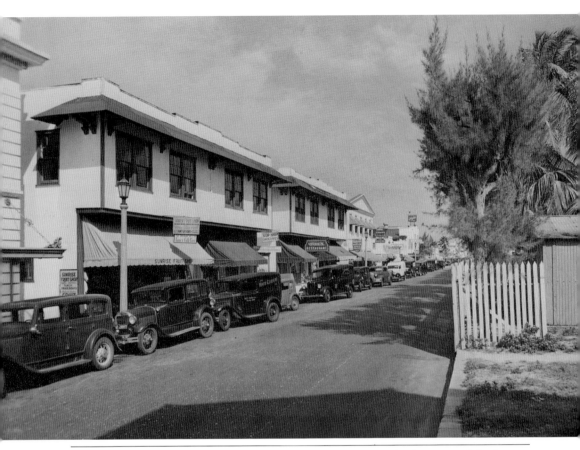

During the Roaring Twenties, Main Street was a bustling hub of restaurants, clubs, and stores located on the north side of the road. Before the 1930s, the one-lane road had barracks for seasonal hotel workers and the first town hall. Though the artery has been expanded, the main attractions are still on the north side of the road. The barracks and old town hall have been removed and replaced with a wide, beautiful median.

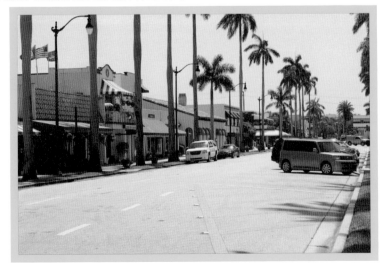

Just east of the entrance to the Flagler Memorial Bridge, a water tower stood like a sentinel guarding entry to the island. During road construction projects in the 1930s and 1940s, the water tower was dismantled. Cocoanut Row was cut north from Royal Palm Way to intersect with Royal Poinciana Way and Bradley Place. The water tower stood in the center of this intersection.

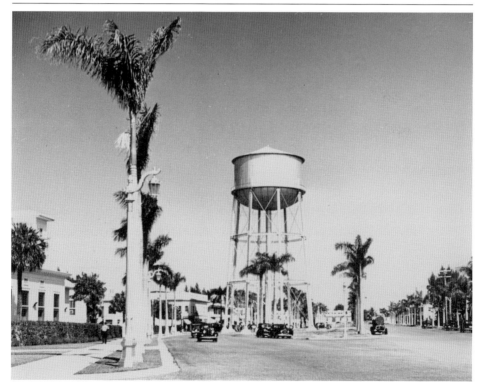

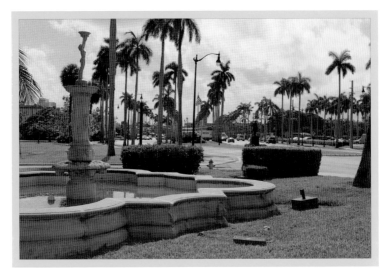

Amy Guest donated the eye-catching fountain at the west side of Bradley Park in 1938. The fountain came from the Guest's pre–World War I oceanfront estate, Villa Artemis. The original fountain had an east-facing female holding a large pitcher in the center. It was later changed to the current southward-looking female statue holding a bowl toward the sky as if to catch falling rain.

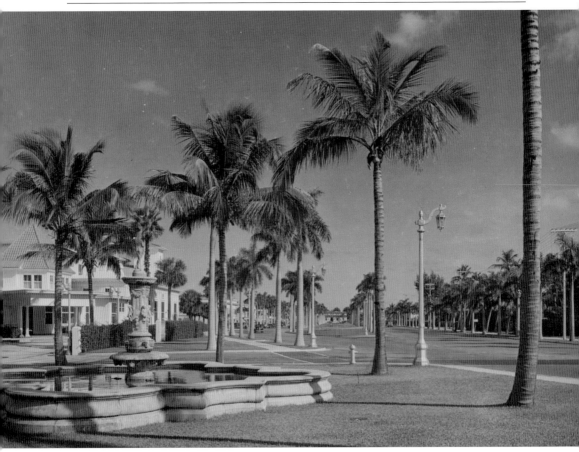

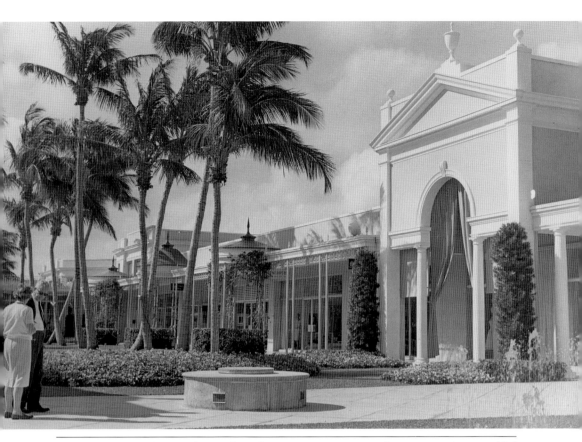

Bessemer Properties hired architect John Volk to design the Regency-style Royal Poinciana Plaza. Built on the grounds of the former Hotel Royal Poinciana, the shopping center opened in 1958 and featured 40 businesses. Some of the early shops to open included Abercrombie & Fitch, Hattie Carnegie, and Gucci. In 2008, it was added to the town's register of historic places. Owners of the plaza have recently been discussing the controversial possibility of redeveloping the plaza as a mixed-use business-residential area.

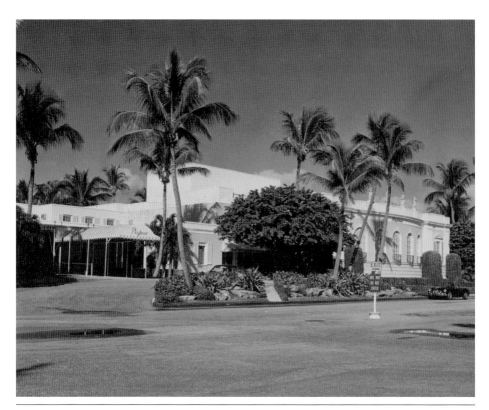

John Volk also designed the Regency-style Royal Poinciana Playhouse to match the Royal Poinciana Plaza. Overlooking the Intracoastal Waterway and anchoring the west end of the plaza, the 900-seat playhouse cost $1.5 million to build. It opened in February 1958 with *Holiday for Lovers*, staring Robert Cummings. Decades later, many well-known actors had performed at the Royal Poinciana Playhouse. The esteemed theater closed its doors in 2004. Protected by restrictions, one day the playhouse many once again feature world-renown performances.

A section of the Hotel Royal Poinciana had been damaged during the 1928 hurricane. To replace that section, the slat house was constructed. The octagonal section of the greenhouse is the only section to survive the demolition of the hotel in the 1930s. Two decades later, John Volk renovated the building that housed the Palm Beach Playhouse and WPTV Channel 5. It received another face-lift in the 1980s, and now medical and dental offices and a restaurant occupy the building.

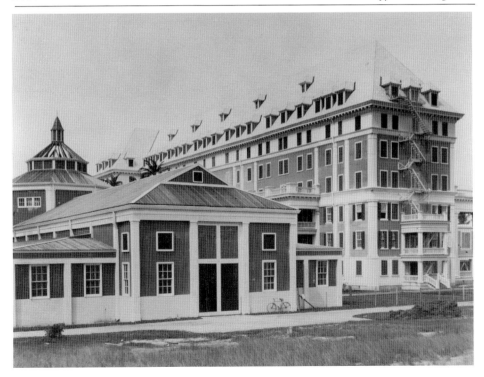

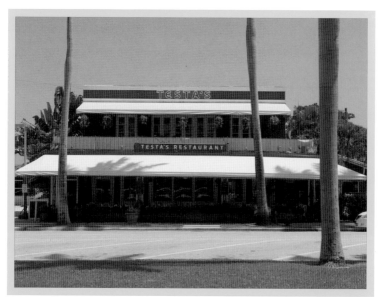

At 221 Royal Poinciana Way is the town's oldest restaurant, Testa's. For over 90 years, the very popular restaurant has been located on Royal Poinciana Way. Testa's was founded in 1921 when Michele Testa opened his eatery in the Garden Theater. Eight years later, the establishment moved to a new location a few doors to the east at 207 Royal Poinciana Way. In 1947, Testa's moved to its current location. The family still owns and operates the restaurant.

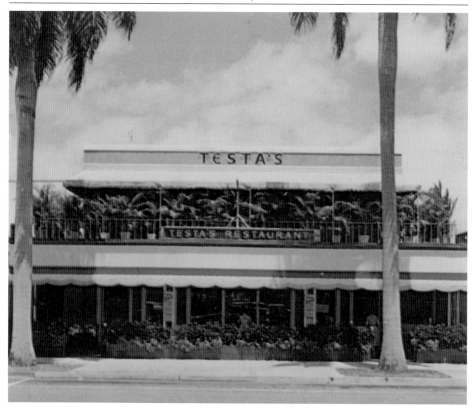

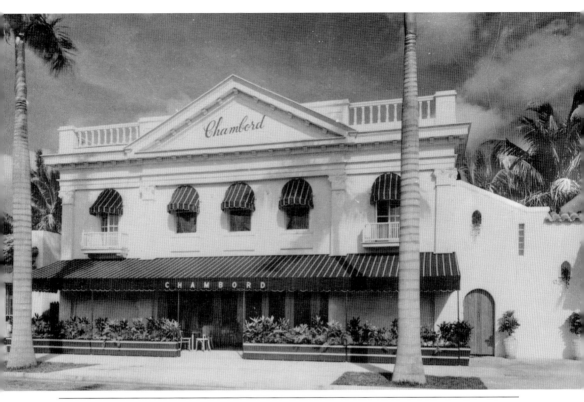

The Palm Beach Book Store at 215 Royal Poinciana Way leases the first floor of the old Garden Theater. At a cost of $75,000, the Neoclassical building was constructed in 1922 for town councilman J.T. Havens. The 800-seat theater opened with Cecil B. DeMille's *The Affairs of Anatol*. In the 1930s, the Sparks Movie chain took over the theater. By the next decade, the Chambord Restaurant occupied the building, providing fine French cuisine and a gypsy violinist to entertain guests.

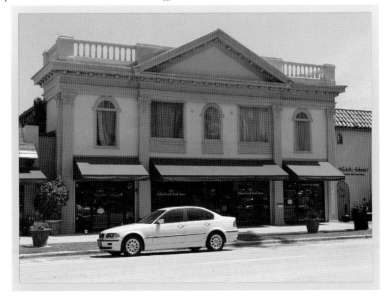

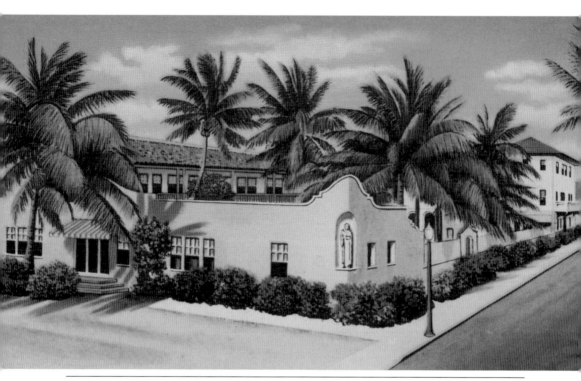

The Institutum Divi Thomae complex was a Catholic scientific research facility from the University of Cincinnati. It first began as a sports complex in 1914 and was later redesigned by Joseph Urban as the Oasis Club for men. After the club closed in the 1930s, owner Edward R. Bradley sold it to the institute. In 1980, the complex was purchased by developers and demolished to make way for Leverett House, seen here on Main Street looking northeast.

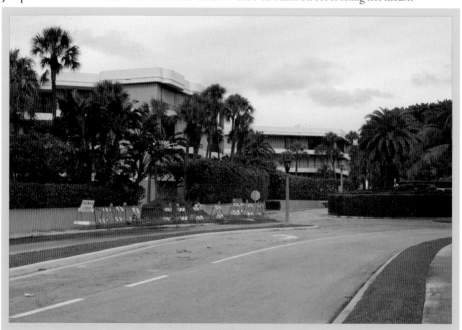

4

OCEAN BOULEVARD

One of Palm Beach's most beautiful roads is Ocean Boulevard, which extended from the north end of the island to Delray Beach. Now one can drive all the way to Miami. When it first opened about 1916, it ran right along the ocean. After the hurricanes of 1926 and 1949, sections of the road were moved west of the ocean. The ocean road is lined with condominiums, mansions, and hotels.

Built in the 1920s, the Palm Beach Inlet Dock was used by locals and port pilots. By the 1940s, Anne Eggleston, known as Inlet Annie, ran the bait shop at the pier selling fish bait, food, fuel, and boating supplies. After 25 years, the town closed the popular meeting place because of complaints about litter, parking, and too many visitors. The bait shop was eventually condemned and demolished in the 1980s. The town built a new smaller concrete pier.

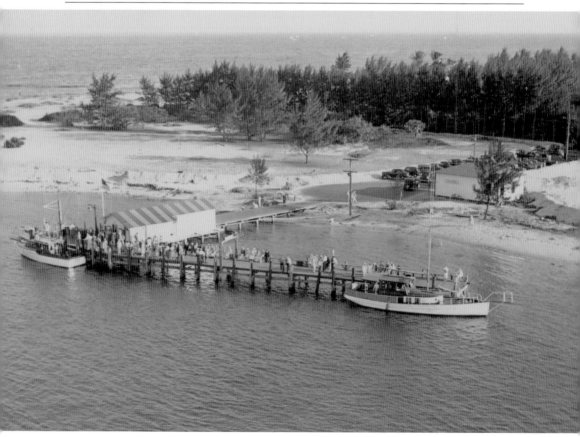

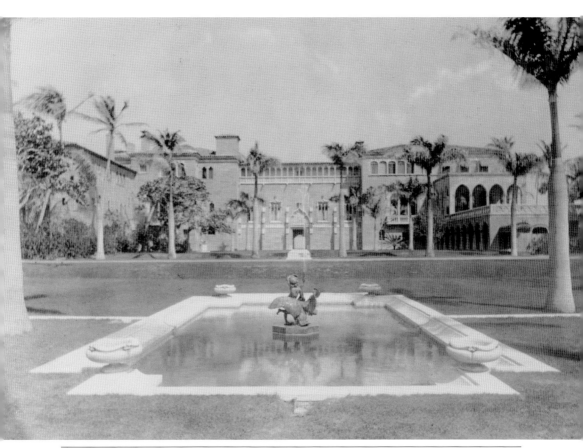

At 947 North Ocean Boulevard, a new house is currently under construction on the site of the largest of Mizner-designed houses, Playa Reinte, meaning "Laughing or Smiling Beach." In 1923, Joshua Cosden commissioned Addison Mizner to design the 70-room palace on 27 acres of lake-to-ocean property. Anna Dodge bought it and then married her real estate agent Hugh Dillman. In 1957, after a failed attempt to sell the huge mansion, it was razed and the property subdivided.

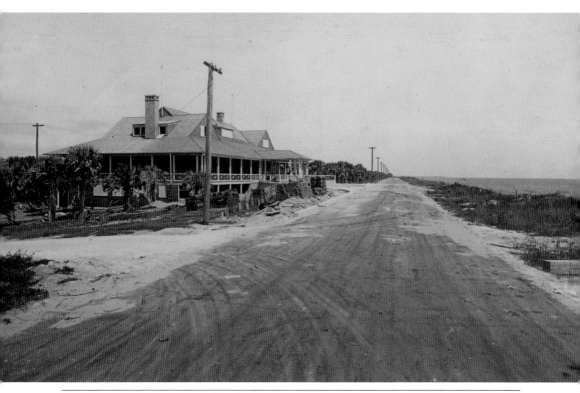

Almost hidden from view is the Palm Beach Country Club at 760 North Ocean Boulevard. Originally built in 1916 on the grounds of the Florida Gun Club, it was intended for guests of The Breakers and Hotel Royal Poinciana. After opening, it became a popular venue for sports and social gatherings. Donald Ross designed the golf course. It sold in 1952 and has been renovated several times, and it is now one of the most exclusive clubs on Palm Beach.

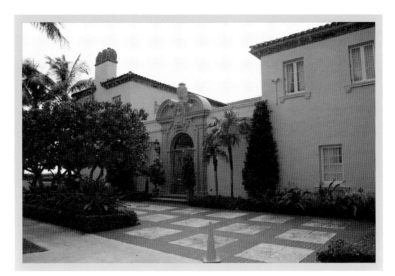

The 1924 Spanish Baroque residence at South Ocean Boulevard and Clarke Avenue was designed by Marion Sims Wyeth. Head of the First National Bank of Palm Beach, Wiley R. Reynolds Sr. had commissioned the home, which actually has its entry on Clarke Avenue. The 14-room house underwent renovations in 1978 and 1987 and was sold in 1989 for $3.5 million. Public records show it sold for $4.7 million in 2000.

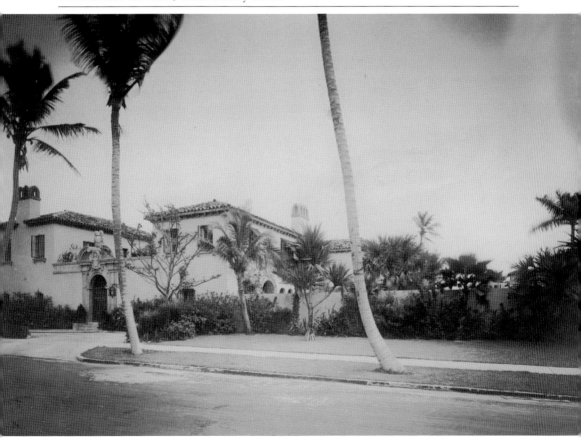

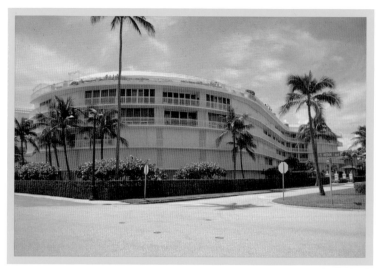

In 1923, Addison Mizner designed the 30-room, Italian Renaissance–style mansion for industrialist George L. Mesker. With an ocean view, the house sat at South Ocean Boulevard and Royal Palm Way. Later, Maurice Fatio redesigned it into a Tudor-style manor. It sold in 1948 and then again in 1968, when it was demolished. It took less than two weeks to raze La Fontana to make way for the distinctive S-curved, six-floor, 39-unit One Royal Palm Way Condominium designed by Howard Chilton.

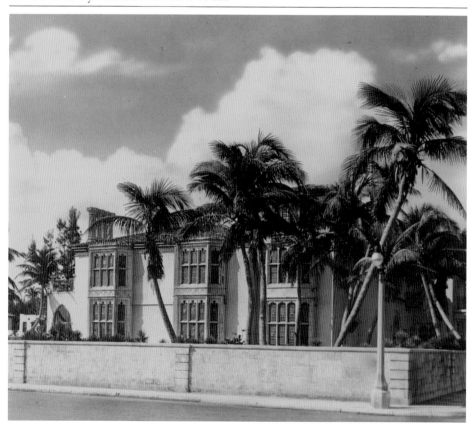

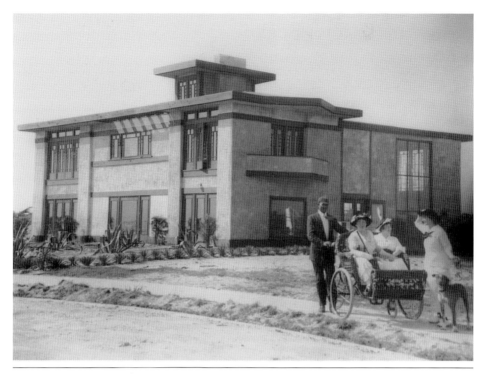

By 1914, on prime, oceanfront property, Chicago photographer William L. Koehne built Zila Villa, named for his wife. The house is said to have been the first house built along the ocean south of The Breakers. There is debate if fellow Chicagoan Frank Lloyd Wright designed the villa. In 1949, Belfort Shumate transformed the house into the Shorwinds Motor Hotel. By 1974, it was sold and demolished to make way for the elegant Dunster House condominiums at 360 South Ocean Boulevard.

In 2011, in celebration of Palm Beach's centennial, a small bell tower was erected on the site of the Palm Beach Pier. A bronze plaque on the wall commemorates the pier. At Worth Avenue and South Ocean Boulevard, Gus Jordahn built the 1,095-foot Rainbo Pier in 1925. Sold in 1931, the pier's new owners added a coffee shop, liquor store, and restaurant. Several hurricanes in the 1940s and 1960s doomed the pier, and it was dismantled in 1969.

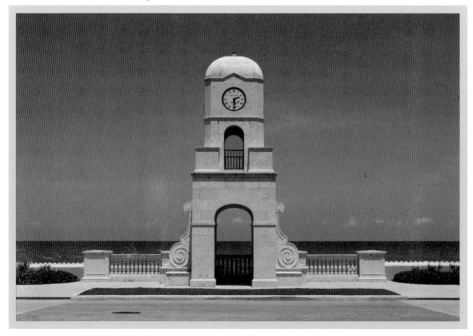

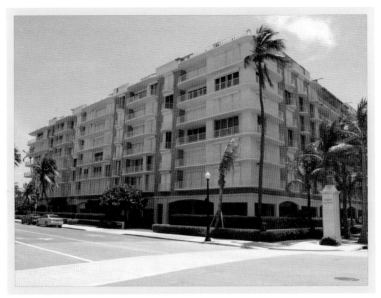

In 1970, Michael Burrows built Winthrope House condominium on the site of Lido Pools, one of Palm Beach's favorite ocean-side attractions. Lido Pools started as Gus's Bath, established by Gus Jordahn. Due to financial problems, the baths were sold at auction in 1931 and renamed Lido Pools. In the late 1960s, Lido Pools was sold and demolished to make way for the eight-floor Winthrope House, a 121-unit condo with a private beach tunnel at 100 Worth Avenue.

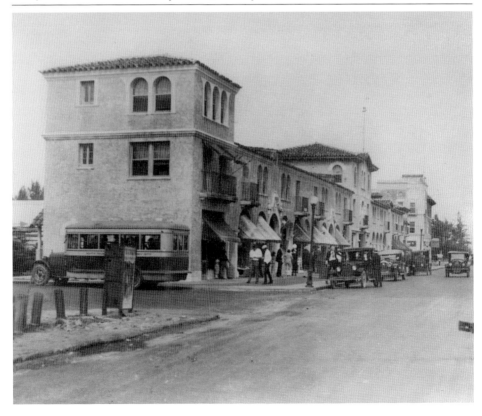

Lionel and Alma Wertheimer opened Wert's Restaurant at 456 South Ocean Boulevard in 1944. The popular restaurant was a great place to grab a bite to eat while enjoying the ocean view. In 1974, the Wertheimers' son Jack sold the restaurant to Harold Kaplan, who renamed the eatery Willoughby's. It was later bought by the Muer Seafood Restaurant chain and reopened in 1980 as Charley's Crab, and then Houston-based Landrys, Inc., took over the business in 2002.

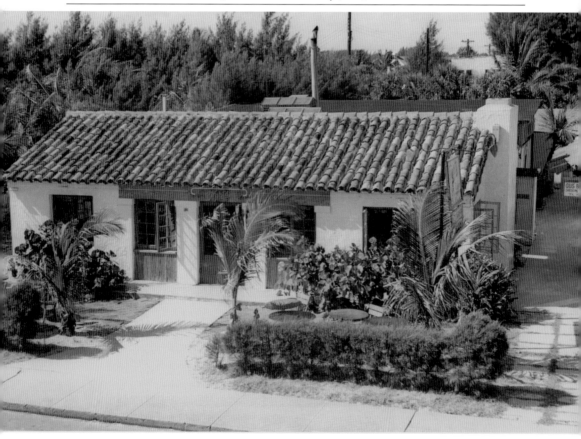

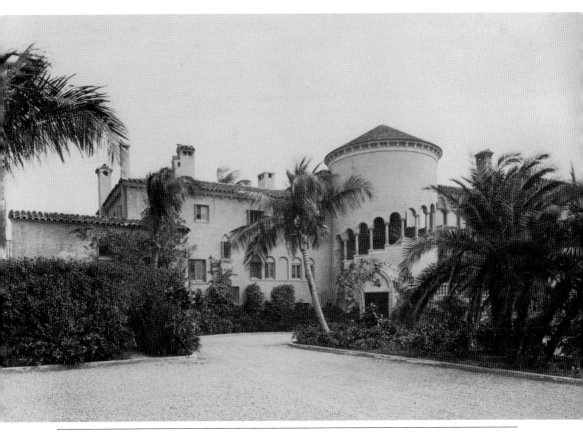

The 1926 Mizner-designed, Venetian Gothic–style, oceanfront estate was built for National Tea Company president George Rasmussen. Unique features of this house include a movie theater with concession stand and the west-side turret-like open staircase. This staircase is often debated, and although untrue, some writers claim that it was an after-the-fact addition. The view of the turret from County Road is now mostly obscured. In 2009, the owners listed Mizner's last Palm Beach commission for sale for a record $72 million.

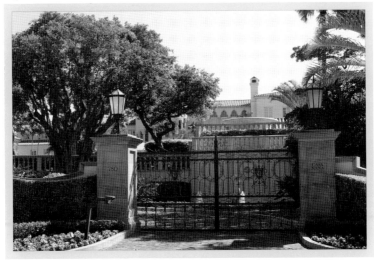

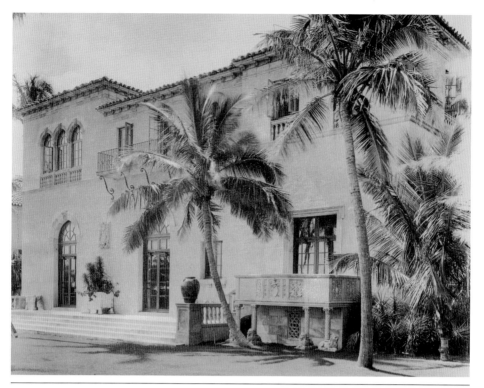

At the south corner of South Ocean Boulevard and Clarendon Avenue sits a large, empty-walled lot. This was the location of the 1923 Casa Florencia, the Palm Beach home of Dr. Preston Pope Satterwhite and his wife, Florence. They were so pleased with Addison Mizner's design that they had his portrait sculpted in bas-relief to add to the facade of the house. Casa Florencia met its demise in the 1950s when it was demolished.

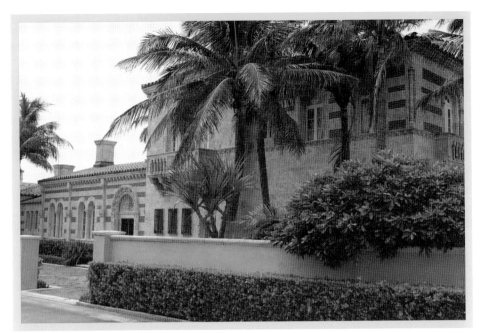

South of the former site of Casa Florencia is one of the most identifiable houses on South Ocean Boulevard, the Mortimer Schiff house, Casa Eleda. Maurice Fatio designed the 1928 home for Schiff and his wife, Adele. Their home is named after Adele spelled backwards. Fatio used coquina stone layered with redbrick to give the house a unique appearance and its nickname, "ham and cheese house." In 2011, the most recent owners offered Casa Eleda for sale at $22.5 million.

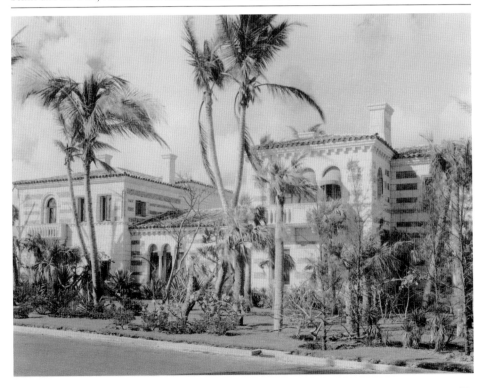

Cielito Lindo, meaning "A Little Piece of Heaven," was the 45,000-square-foot home of Jessie Woolworth and her husband, James Donahue. Marion Sims Wyeth designed the $2-million mansion in 1927 on lake-to-ocean property. In 1946, Jessie sold it to developers for $100,000. Architect Byron Simonson dismembered the house, demolishing the living room to construct the present-day Kings Road. The rest of the colossal house was divided into five villas located on Kings Road.

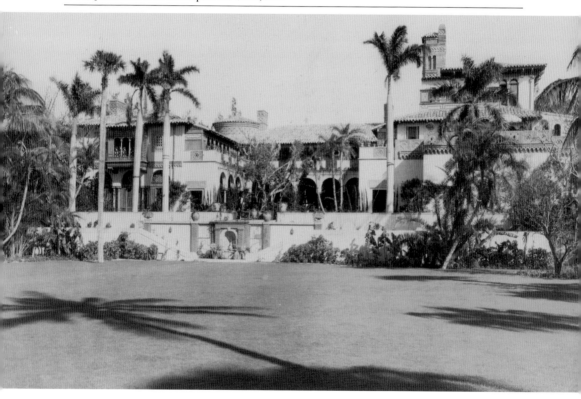

Four Winds, a 1937 Bermuda-style home designed by Maurice Fatio for Edward F. Hutton, did not escape the wrecking ball. The landmark structure, overlooking the ocean, sold for $20.3 million in 2003. The owners had received approval for renovations. During construction, underlying structural problems were revealed and the house was demolished, causing an uproar with some preservationists even though the owners were within their rights. A larger version of the original South Ocean Boulevard house was constructed on the site.

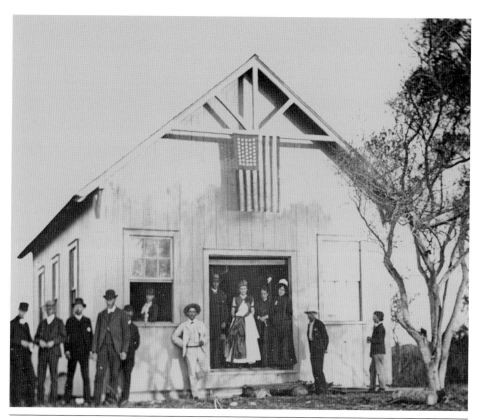

The first schoolhouse in southeast Florida was constructed in 1886 on what is now Palm Beach. The building was located at the north end of the island about one mile north of the present-day Flagler Memorial Bridge. The historic schoolhouse is now located at Phipps Ocean Park on South Ocean Boulevard. The Preservation Foundation of Palm Beach operates a living history program called the Little Red Schoolhouse at the old structure.

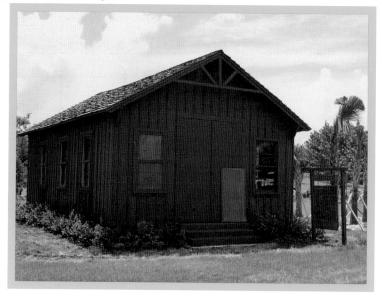

CHAPTER

5

COUNTY ROAD

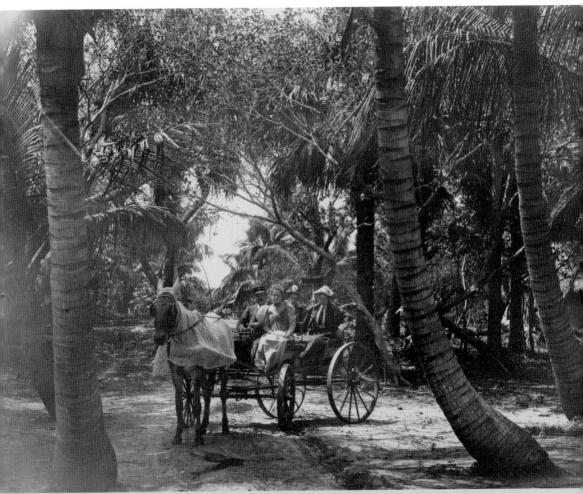

County Road cuts through the center of Palm Beach. Prior to the 1928 hurricane, which tore out North Ocean Boulevard, County Road (Palm Beach Avenue as it was then called) ended at Wells Road. After the storm, County Road was then extended through numerous lakes to ocean estates north of Wells Road. An early-20th-century photograph shows a horse-drawn wagon with riders on the dirt pathway.

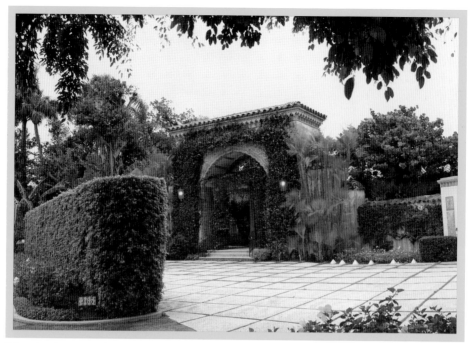

Edward and Eva Stotesbury hired Addison Mizner to design their oceanfront home, El Mirasol, "The Sunflower." The 40-room, Mediterranean-style mansion sat on 40 acres stretching from lake to ocean and included gardens, a dock, and a private zoo. After the 1928 hurricane destroyed the oceanfront gate entry (shown below), Maurice Fatio designed a new entrance on North County Road. El Mirasol was demolished in the 1950s to make way for El Mirasol Estates. The Fatio gate still stands on North County Road.

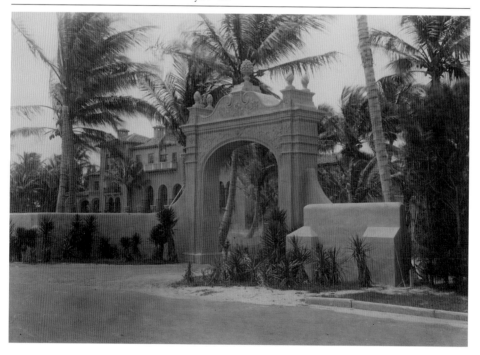

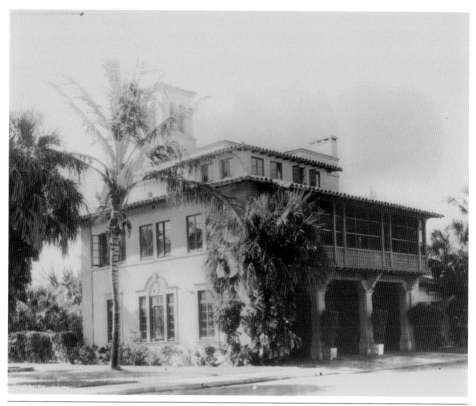

Clark J. Lawrence designed the 1927 Fire Station No. 2 at 300 North County Road with later additions by Addison Mizner and Maurice Fatio. In the 1980s, the station faced destruction, but preservationists rallied to save the building. The restoration by Jeff Falkanger and Associates and Catherine D. Lee modernized the building and added 3,000 square feet. One of the town's first two fire stations, this one is the only one still in use as a fire station.

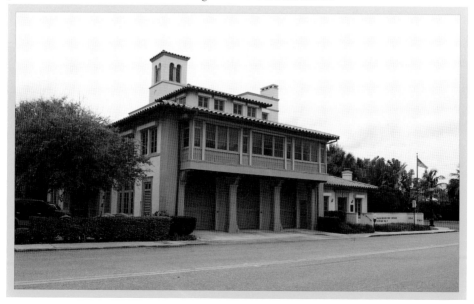

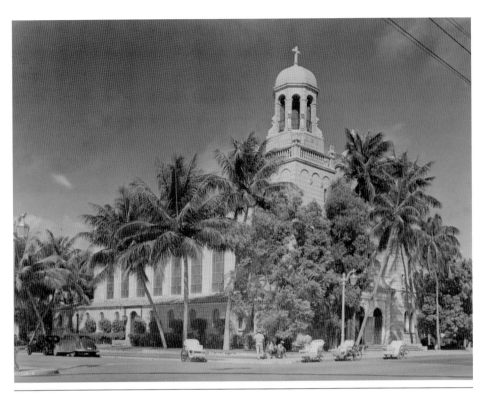

Mortimer D. Metcalf designed the 1926 double-towered, Spanish Renaissance–style St. Edward Catholic Church at the northwest corner of North County Road and Sunrise Avenue. Almost 300 people contributed $500,000 to build the church, including Edward R. Bradley as the leading donor. When in town, Pres. John F. Kennedy and his family often attended mass at St. Edward. In 1997, architect James Anstis oversaw the renovation of the second-oldest Catholic church in the Diocese of Palm Beach.

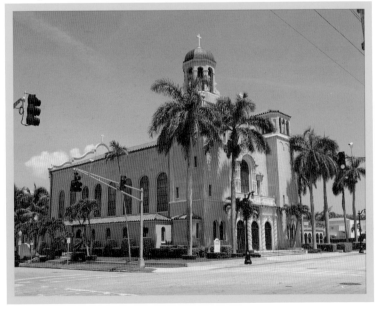

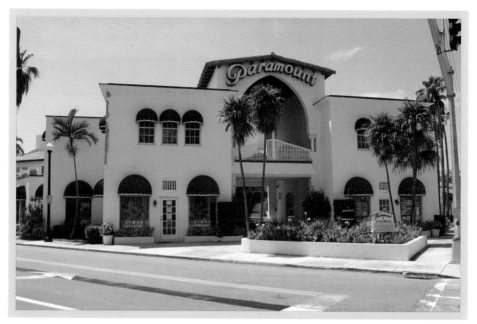

Austrian architect Joseph Urban originally designed the 1927 Paramount Theater as a multiuse facility for first-run movies with space for shops, offices, and a restaurant. The theater closed in 1980 and is now owned by the nondenominational Paramount Church. The Mediterranean Revival–style building is a great example of commercial adaptive reuse with shops, offices, and a church. Surviving several hurricanes over the years, the Paramount is listed in the National Resister of Historic Places and the town's local historic register.

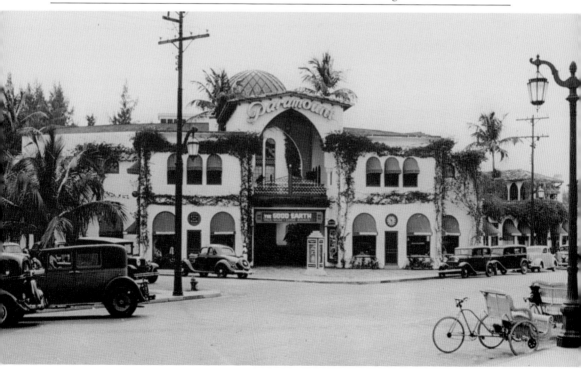

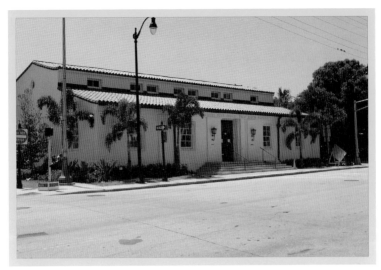

Architect Louis A. Simon designed the 1936 two-story, Mediterranean Revival–style Palm Beach Post Office Building. In the lobby, above the doorway, are murals painted by artist Charles Rosen in the 1930s depicting Seminole Indian life. Located at 95 North County Road, the post office became a victim of budget cuts. In 2012, billionaire Jeff Greene purchased the landmarked building for $3.7 million for his company Florida Sunshine Investments, Inc. The post office has relocated to Royal Poinciana Plaza.

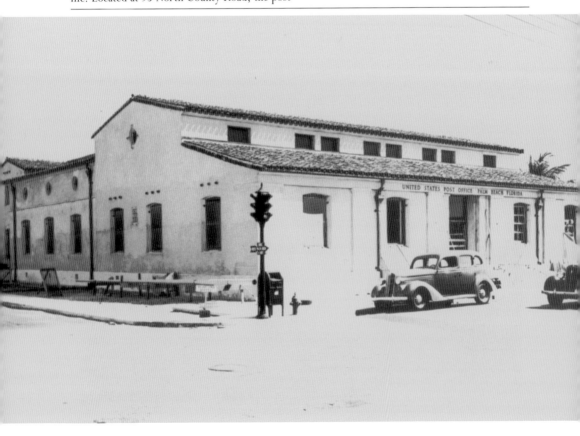

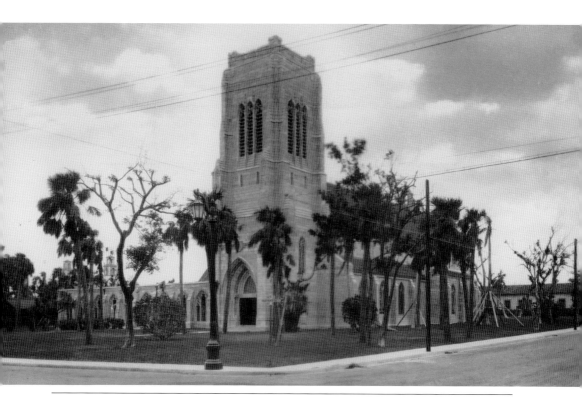

When the old Episcopal Church of Bethesda-by-the-Sea on North Lake Trail became too small, the New York firm of Weeks and Hiss designed the Gothic-style Bethesda-by-the-Sea at the corner of South County Road and Barton Avenue. Construction began in 1925 and was completed in 1927. Striking stained-glass windows have replaced the plain windows. Following Sunday services, tours are offered revealing the interesting history of the church and artifacts.

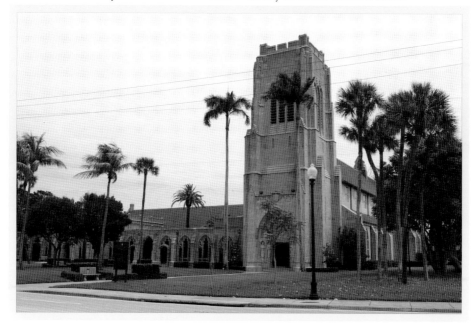

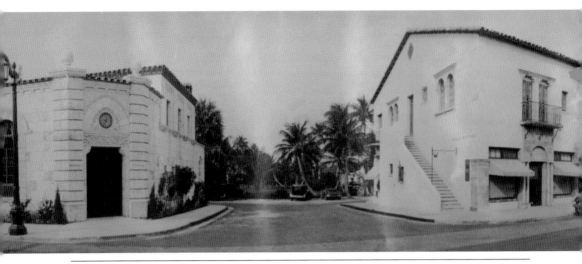

Surrounding an elliptical green space, Phipps Plaza Historic District is a unique neighborhood right off County Road with a mix of Mediterranean and Bermudian architecture. Designed in 1925 with only one entry/exit, town houses, cottages, and offices occupy this small plaza, which was developed by John S. Phipps. Several architects who assisted with the development of the dual-purpose location include Addison Mizner, Maurice Fatio, John Volk, and Marion Sims Wyeth. It continues to be a commercial and residential area.

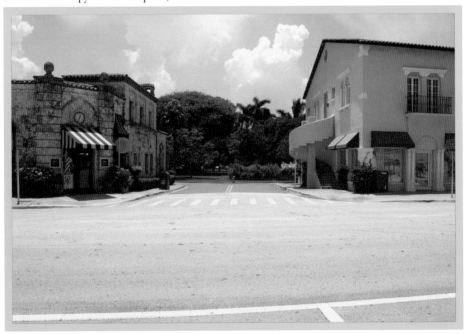

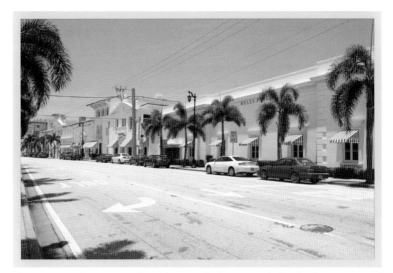

At 255 South County Road, just across from Phipps Plaza, is the 1925 First National Bank Building, designed by Marion Sims Wyeth. Between 1927 and 1955, architects Maurice Fatio and John Volk added their touches to the building. It originally had a Moorish facade, but it was replaced with a Neoclassical temple-like front by Volk. Since 2008, Wells Fargo Bank has occupied the historic building. Even so, the structure retains the name of First National Bank.

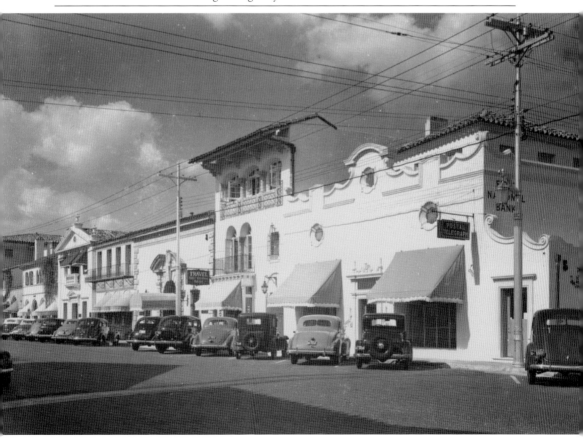

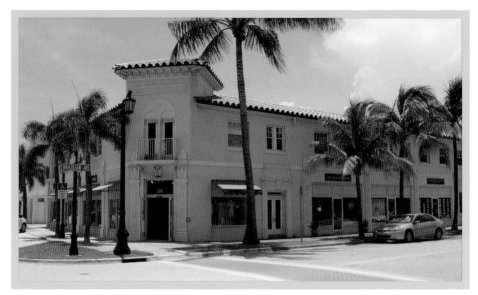

In 1925, the architectural firm of Harvey and Clarke designed the Mediterranean Revival–style Palm Beach Daily Newspaper Building for publisher Oscar G. Davies. Located on the southwest corner of County Road and Brazilian Avenue, the "Shiny Sheet," as the locals call the newspaper, was published here until 1974, when the office moved to Royal Poinciana Way. The building is part of the Town Hall Square Historic District and now houses offices and stores.

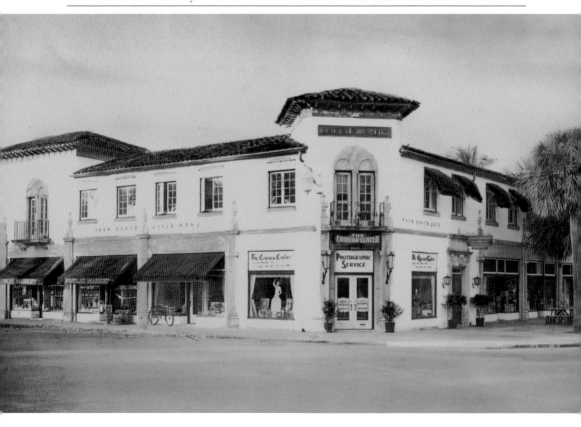

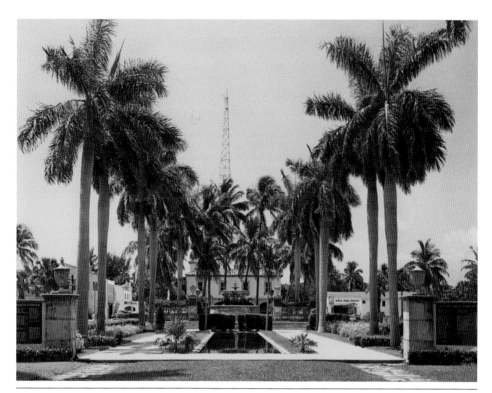

Just north of town hall is the Mizner-designed Memorial Fountain, dedicated in 1930. It honors Henry Flagler and Elisha N. Dimick for their contributions to the development of Palm Beach. It has a reflecting pool and an 18th-century-inspired sea horse fountain. The World War II memorial plaque was added later and now honors town employees who died in the line of duty. Town government and preservationists have recently committed $300,000 for the restoration of the fountain.

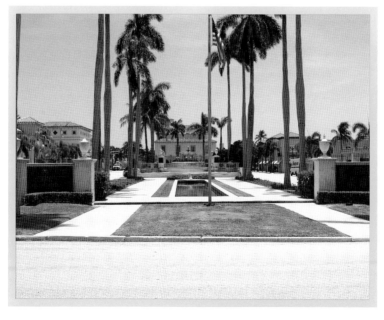

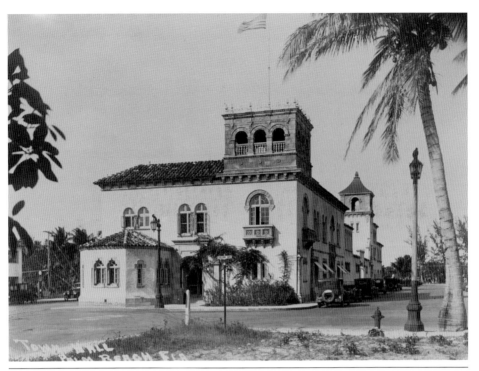

In the center of South County Road is the 1926 Mediterranean Revival–style town hall. Architects Henry Harvey and Louis Clarke designed it as two separate buildings with a walled courtyard between them. The south building held the town government and police station, and the north structure housed the central fire station. After the 1965 and 1989 renovations, it became one complete building. A $12-million renovation was completed in 2010, just in time for the town's centennial the following year.

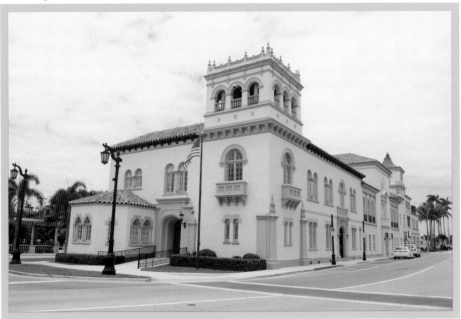

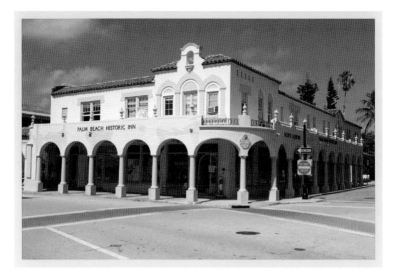

Located at 365 South County Road is the Buckley Building designed by the local architectural firm Harvey and Clarke and constructed in 1925. When it opened, it was known as the Palm Beach Stores, Inc., a grocery store owned and managed by winter residents. The landmarked Mediterranean-style structure is now the Palm Beach Historic Inn. Billed as the "only bed-and-breakfast on the island," it is has nine rooms and four suites with all the modern amenities.

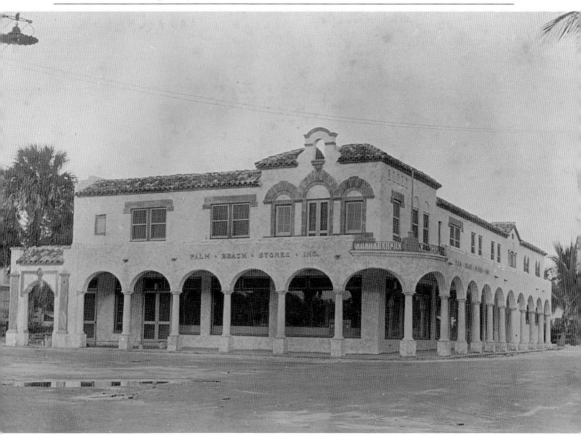

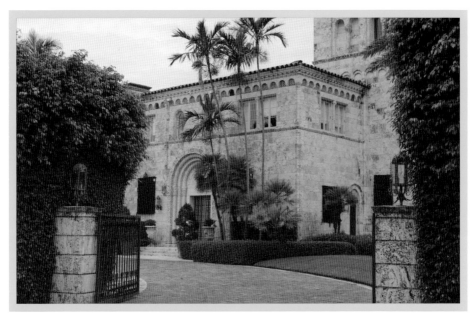

At 195 Via Del Mar, just off South County Road, is one of Maurice Fatio's greatest houses, Casa della Porta del Paradiso, "House of the Door of Paradise." Fatio designed the 1928 Romanesque Florentine–style house for automobile executive William J. McAneeney. The name of the house comes from the ornately carved doorway, which took Italian stonecutters months to carve. In recent years, the landmarked villa has been restored and sold for $13.9 million in 2009.

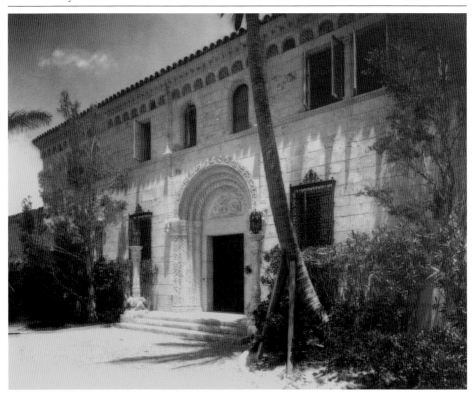

WORTH AVENUE

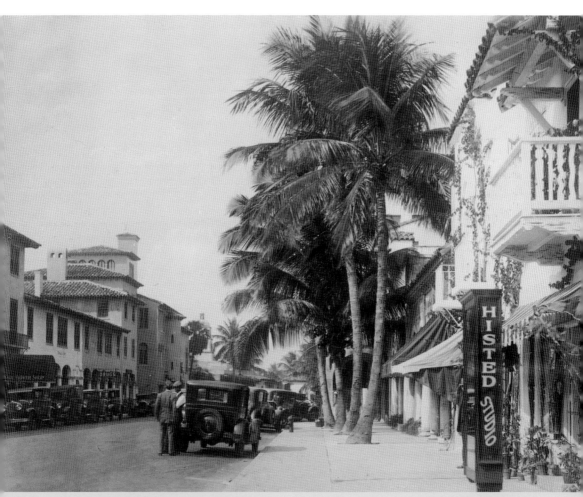

Here is a 1920s westerly view of Worth Avenue. Life began for the fashionable shopping street when the Everglades Club opened in 1919. Over the decades, the road named for the Second Seminole War commander, Col. William Jenkins Worth, became a world-renown shopping destination. In 2010–2011, the avenue received a well-deserved $15.8-million makeover, completed in time for the centennial celebration.

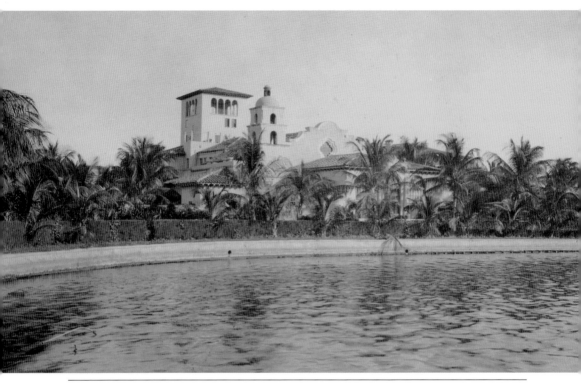

In 1918, Addison Mizner designed the Spanish Moorish–style would-be World War I hospital that was converted into a club. Paris Singer opened it as the Everglades Club in 1919 as an elite private establishment built on a dirt road that ended at a lake basin. That dirt road would become the most famous road in Palm Beach, Worth Avenue. The club has expanded and undergone changes as can be seen in the recent image of the club.

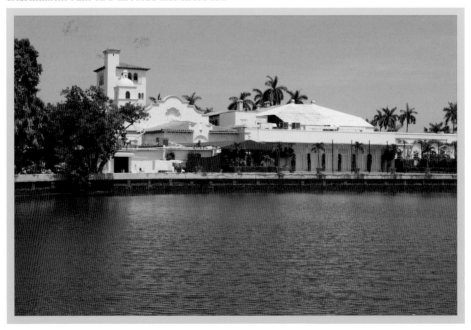

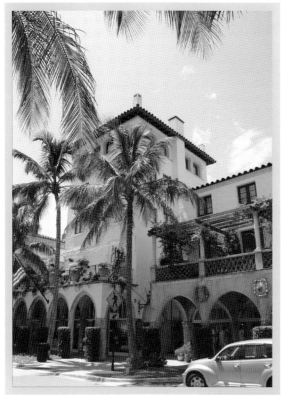

Via Mizner (named after Mizner's apartment building) is architect Addison Mizner's interpretation of an intimate, meandering, Venetian-style street. Built in the 1920s between Worth and Peruvian Avenues, the winding, pedestrian lane is occupied by restaurants, shops, residences, and offices. At the entrance of the via is Mizner's five-story apartment building (pictured here), which overlooks the surrounding environs. Courtyards, archways, balconies, and gardens, all with a Mediterranean-style flavor, complete the lane. Via Mizner is listed in the National Register of Historic Places.

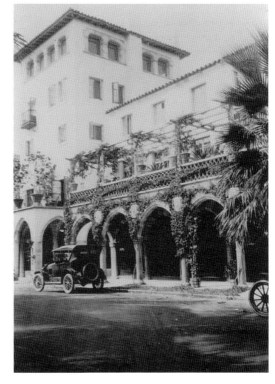

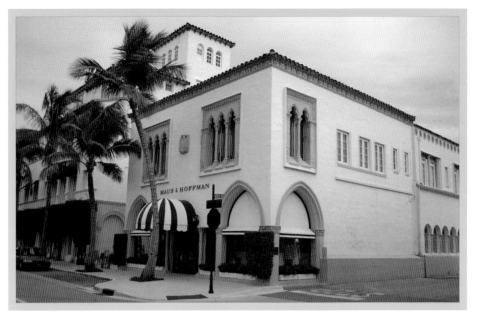

In the 1920s, at Golfview and Worth Avenue, Lester Geisler designed the two buildings shown at the right, a four-story building to the east and a two-story building on the west. A second-floor passageway over a patio connects the two structures. Saks Fifth Avenue leased the east building, which is now occupied by Ralph Lauren. The Cadillac Motor Company set up shop in the two-story building. Since the 1960s, it has been the home of the men's haberdashery, Maus and Hoffman.

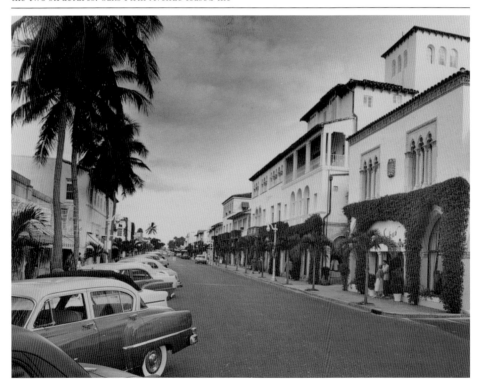

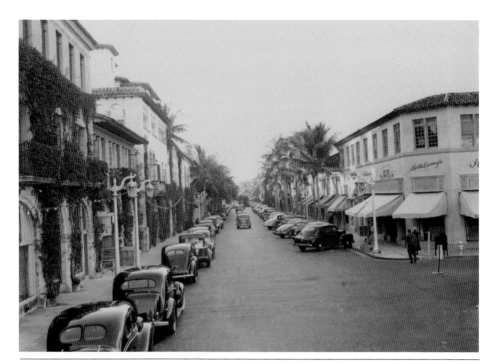

On the right is Hattie Carnegie's women's clothing, hats, and jewelry store, which occupied one of the most prominent locations on the avenue. Hattie's first Palm Beach store opened in the Paramount Theater in the 1930s. She then relocated to Worth Avenue at the corner of Worth and Hibiscus Avenues. In 1957, the store moved to the Royal Poinciana Plaza but closed in the 1960s. Chanel is now located in the recently renovated building at 301 Worth Avenue.

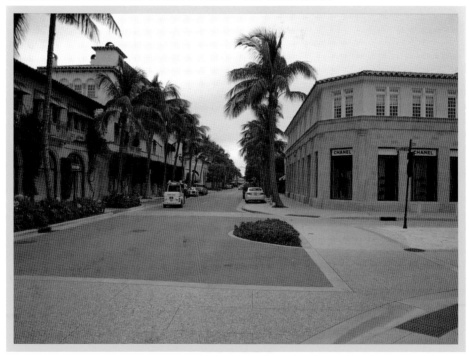

Aldo Gucci first arrived in Palm Beach in the 1950s, opening a store on Worth Avenue. He then moved to Royal Poinciana Plaza and then moved back to Worth Avenue to a shop on Via Mizner. In the mid-1970s, he purchased the Lanfranchi building at 256 Worth Avenue, across from Hibiscus Avenue. Gucci relocated to the Esplande, and since 2012, Via Gucci and the courtyard, originally named Via Lanfranchi, have been unofficially christened Via Amore. The courtyard can be seen through the center archway.

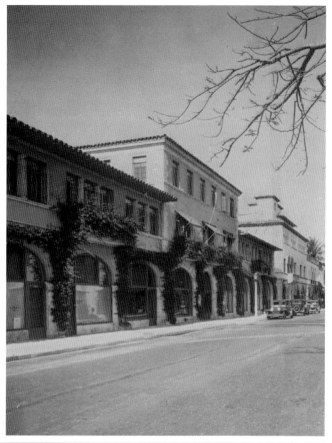

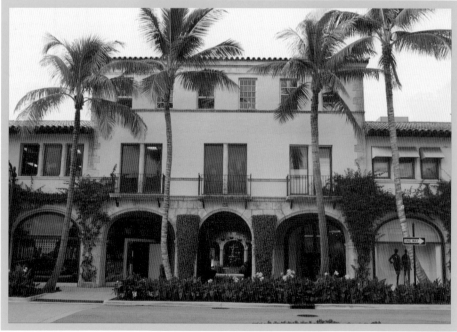

WORTH AVENUE

At 247½ Worth Avenue, on a small unnamed via, Mizner designed a two-story cottage for his brother Wilson in the 1920s. It was the scene of great parties. Wilson helped Addison with the company business; however, when the company failed in the late 1920s, Wilson left. Since then, the cottage has been restaurants and galleries. In 1992, it was demolished to make way for storefronts at 247–245 Worth Avenue. The site is now Chopard, Loro Piana, and Giorgio Armani.

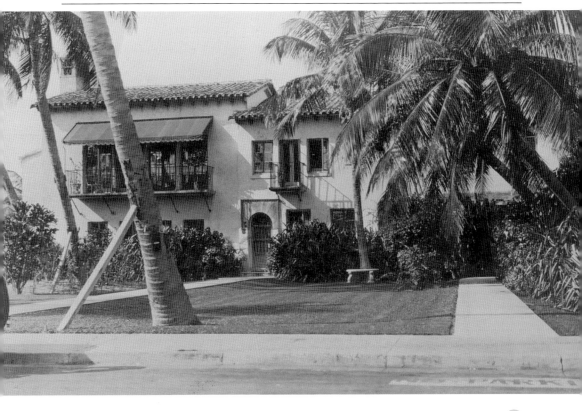

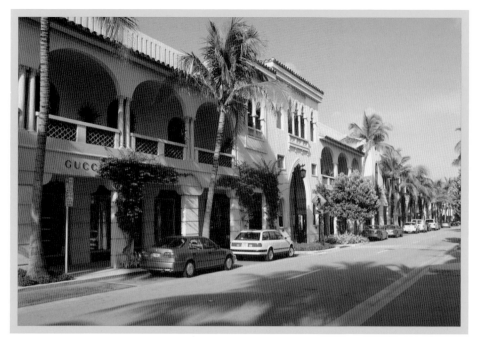

The Esplanade at 150 Worth Avenue is a two-level dining and luxury-shopping complex, which replaced small shops, a gas station, and the Ocean View Hotel. In the 1970s, developer Murray Goodman constructed a new posh shopping destination. The Esplanade covers most of the block from County Road to South Ocean Boulevard. The fashion center has about 40 shops and restaurants, including Saks Fifth Avenue, Gucci, and Starbuck's Coffee.

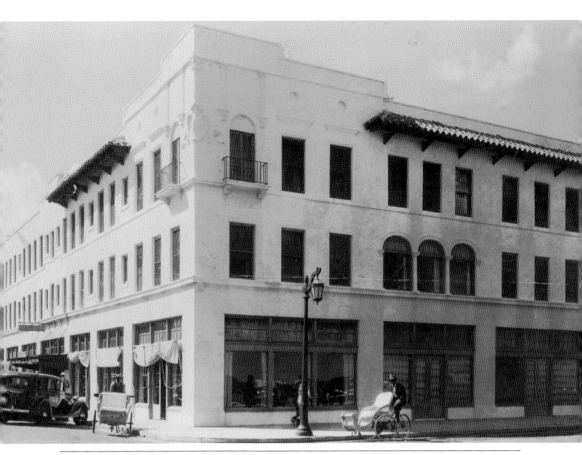

The prestigious six-floor Kirkland House at 101 Worth Avenue opened in the 1970s with 20 units, each having an ocean view. Before condos took over this prime real estate location, it was the Billows Hotel. In 1923, Henry Curtis opened the hotel at the east end of Worth Avenue overlooking the ocean. The name was later changed to the Seaglade Hotel. In 2012, one of the Kirkland House apartments sold for $6.4 million, a record sale for this condominium.

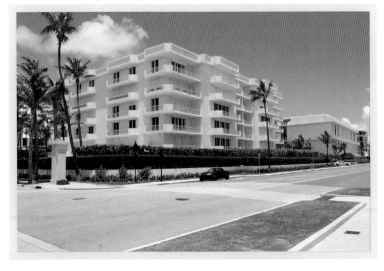

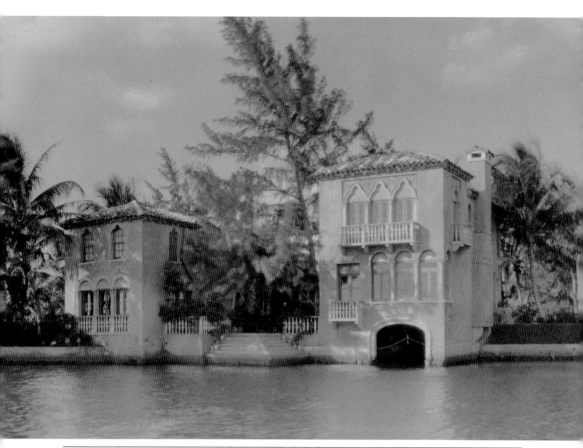

At 450 Worth Avenue, on the first lot just west of the Everglades Club, is Casa de Leoni. Designed in 1921 by Addison Mizner for Leonard Thomas of Philadelphia, this unique two-story, Venetian-style villa extends 20 feet into Lake Worth and is accessible by both water and land. In 1987, European craftsmen completed the renovation of the house. The landmarked home was named for the first owner and for the lion of St. Mark located over the front door.

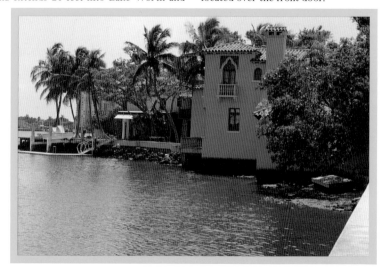

CHAPTER 7

OTHER PLACES

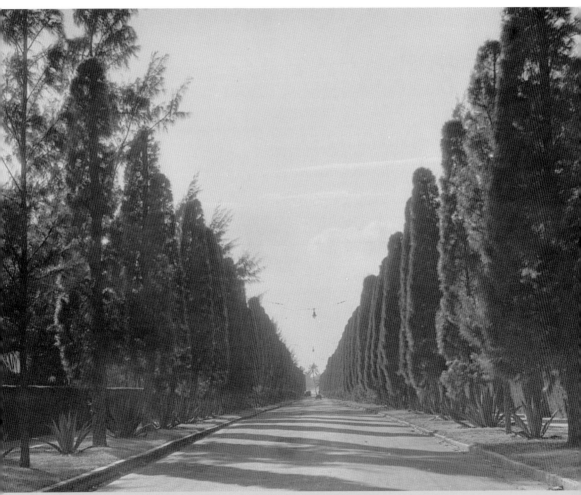

Wells Road dates to the early development of the island. The east-west road crosses the island from the ocean to the Intracoastal Waterway. It is flanked on both sides by nonnative Australian pine trees, which are an essential characteristic and a recognizable feature of the town, and is designated Wells Road Scenic Vista. It was said to be one of the "most picturesque thoroughfares."

Another historic street on Palm Beach is Barton Avenue. Seen here around the turn of the 20th century, the street was nothing more than a sandy pathway lined with the ever-familiar coconut palms. The road is named in honor of early winter resident Cornelius Vanderbilt Barton of New York, who owned property on this lane. Barton Avenue has since been transformed to a modern asphalt-paved roadway lined with palm trees, homes, and the Episcopal Church of Bethesda-by-the-Sea.

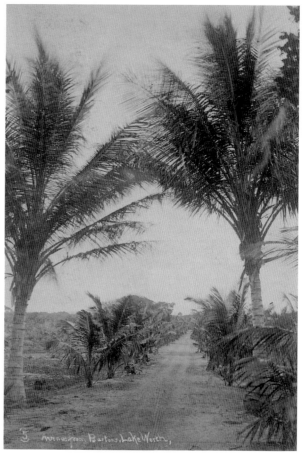

Clarke Avenue is named for Palm Beach resident John Charles Clarke, a millionaire businessman from Philadelphia. In the 1890s, he purchased the Cocoanut Grove House, and shortly afterward, it burned to the ground. He and his family constructed their homes on the property along the Lake Trail. Originally, a pond was located at what is now the intersection of Clarke Avenue and Cocoanut Row. Here, Clarke family members enjoy a lazy winter day on the pond in the late 1890s.

Coral Cut is an unusual geological feature found in an area that is typically flat, sandy terrain. In the 1920s, the limestone ridge was excavated to cut Country Club Road from North Ocean Boulevard west to Lake Worth, providing additional access to the north end of the island. Nothing more than a narrow path when it was cut, it is now a two-lane road. To preserve this distinctive landmark, the town designated the road a historic district in 1987.

OTHER PLACES

Originally named Jardin Latin, Villa Giardino on Peruvian Avenue was the beautiful home and gardens of antiquities dealer Ohan Berberyan. In 1931, he opened the Berberyan Gardens at his residence; the gardens are based on three different European gardens. The original architect of the residence was Marion Sims Wyeth. The garden entry is the same as it was in 1931. The villa was recently offered for sale at $12.8 million but sold in November 2012 for $6.75 million.

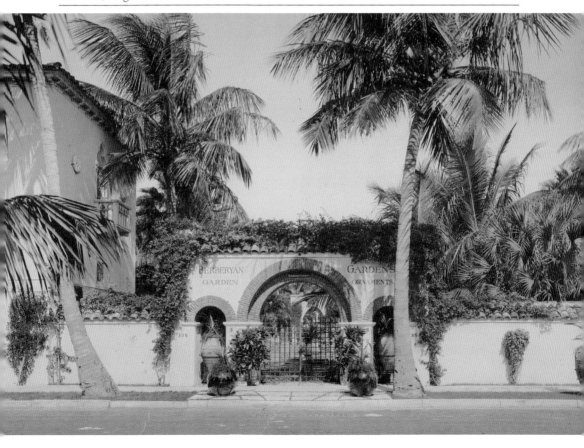

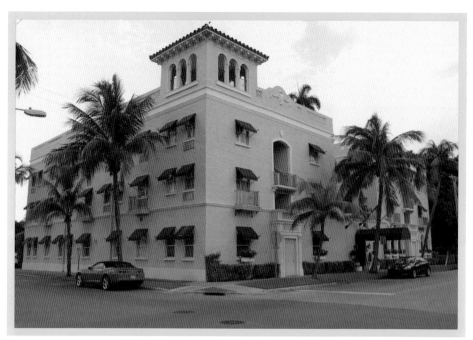

The Mediterranean-style hotel, the Chesterfield Palm Beach, opened in 1926 as the Lido-Venice Hotel at 363 Cocoanut Row. Just two years later, the name changed to Vineta, and in 1937, architect John Volk designed alterations for the hotel. In 1989, over 50 years later, the hotel's name changed to the Chesterfield, now part of the London-based Red Carnation Hotel Collection. A mecca for high society, the hotel has 53 rooms, a cigar room, library, and the popular Leopard Lounge.

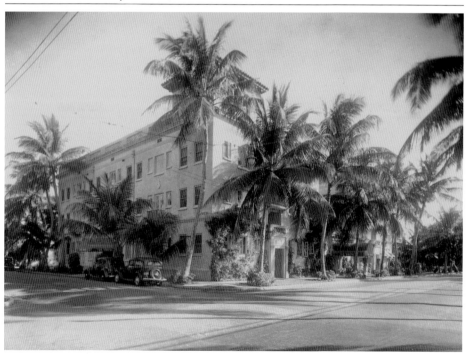

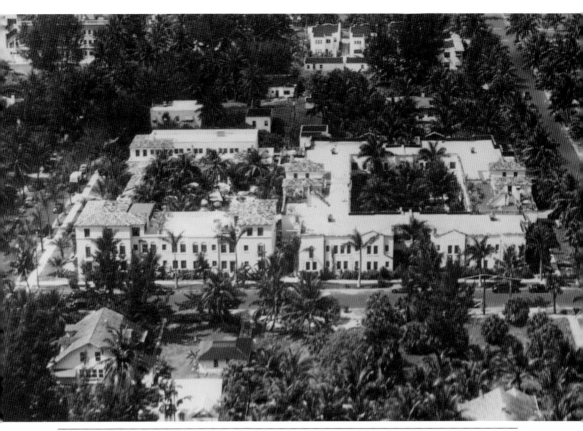

Rosario Candela, a Sicilian-born architect, designed the Mediterranean-style Brazilian Court Hotel in 1925. When it opened a year later, the two-story hotel had 116-rooms around a courtyard. Located at 301 Australian Avenue, Maurice Fatio designed the south wing in 1936, expanding the property from Brazilian to Australian Avenues. The hotel is now a condominium hotel with 80 luxurious studios and suites. Amenities for guests include the internationally known Café Boulud and Frederic Fekkai Salon & Spa.

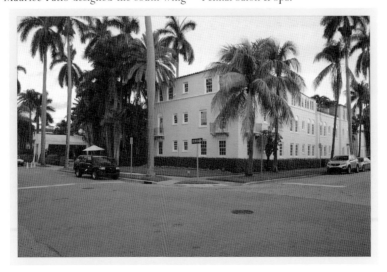

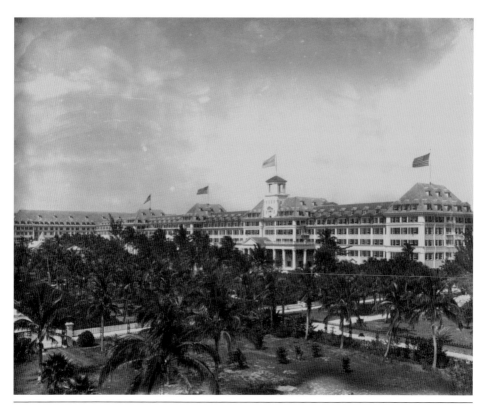

Built in less than a year, the Hotel Royal Poinciana opened in February 1894. By the mid-1930s, Henry Flagler's grand hotel was run down and had suffered hurricane damage. As a result, it was razed, and over 20 years later, the H-shaped Palm Beach Towers, an $8.5-million apartment-hotel, rose in its place. When Pres. John F. Kennedy vacationed in Palm Beach, the Towers became the presidential press headquarters. In 1973, the Palm Beach Towers converted to condominiums.

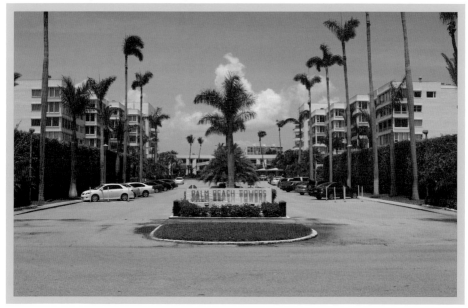